IMAGES
of America

# WILTON

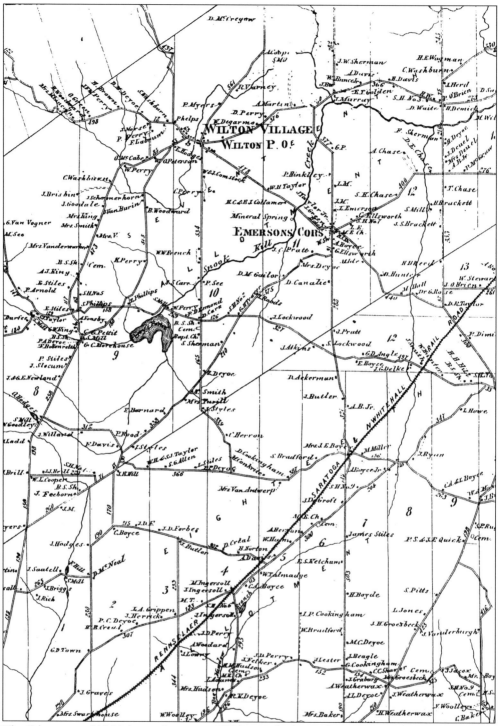

The Beers map of 1866 shows the town of Wilton, which was formed in 1818 from the town of Northumberland. Wilton is bordered by Saratoga Springs to the south, Greenfield to the west, Corinth to the northwest, Moreau to the north, and Northumberland to the east.

IMAGES
*of America*

# WILTON

Jeannine Woutersz

ARCADIA

Copyright © 2003 by Jeannine Woutersz.
ISBN 0-7385-1232-X

First printed in 2003.

Published by Arcadia Publishing,
an imprint of Tempus Publishing Inc.
2A Cumberland Street
Charleston, SC 29401

Printed in Great Britain.

Library of Congress Catalog Card Number: 2003105430

For all general information, contact Arcadia Publishing:
Telephone 843-853-2070
Fax 843-853-0044
E-mail sales@arcadiapublishing.com

For customer service and orders:
Toll-free 1-888-313-2665

Visit us on the Internet at www.arcadiapublishing.com.

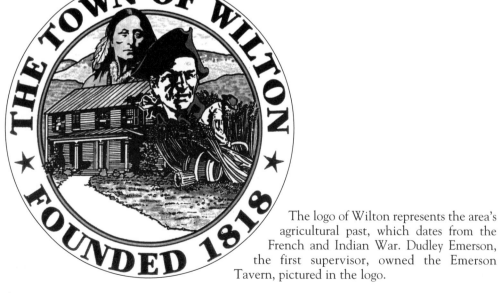

The logo of Wilton represents the area's agricultural past, which dates from the French and Indian War. Dudley Emerson, the first supervisor, owned the Emerson Tavern, pictured in the logo.

# CONTENTS

# ACKNOWLEDGMENTS

This book was made possible only by the dedicated efforts of the Wilton Heritage Society Historic Sites Committee. Special thanks go to Doris Armstrong, founder; Betty Harrington, special assistant; Kathleen Doescher, past president; Carol Parkhurst, house tour chairman; Jean Gainer, treasurer; Dagmar Helenek, president; Beth Pfaffenbach for her knowledge of Grant Cottage; and Emily Brower for her aid with the South Wilton area. Thanks also go to Richard Elwell for his excellent technical support and encouragement, and to Bob Bearor for generously sharing illustrations from his book *Leading by Example*.

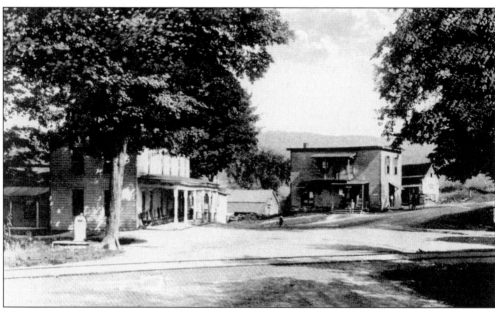

The Saratoga–Glens Falls road, the main street of Wilton, is shown in the early 1900s. Notice the trolley track that went through the center of town. The trolley went north to Glens Falls. On the left is the Wilton Hotel, and on the opposite corner is the post office and general store of Charles Van Rensselaer.

# INTRODUCTION

The one common link between the Native Americans, the early settlers, and the present-day residents of Wilton is the love of the land. As the Iroquois were attracted by the forests, streams, mineral waters, and fertile land, so were the first pioneer families. Trails used by the Native Americans, trappers, and traders were later used by French and British troops in the French and Indian War.

In January 1693, French soldiers left Montreal to attack the settlements of Schenectady and Fort Orange (Albany). On their return, the French troops under the command of Nicolas de Mantet, along with their Native American allies, were overtaken by Maj. Pieter Schuyler and Lt. John Schuyler at Stiles Corners. The three-day battle that followed was fierce and bloody. The French retreated under cover of a snowstorm and crossed the Hudson River on an ice floe. The British followed, but the ice had cleared and they had to give up the pursuit. The Battle of Wilton is noted by a historic marker at the corner of Parkhurst and Gailor Roads.

The Kayaderosseras Patent was issued to Simson Broughton and 12 associates in 1708. The patent included land that became the town of Wilton. Because of the French and Indian War, development of the area did not begin until many years later.

The first settlers came to Wilton (or Palmertown, as it was known earlier) between the French and Indian War and the American Revolution. In 1764, the Brisbin brothers began a sawmill on the Snook Kill, which comes tumbling off the Palmertown mountain range in the northwest section of Wilton. After the Revolution, the families of Stiles, King, Phillips, Laing, Perry, Emerson, Dimmick, Johnson, and McGregor left their marks, as well as their names, on many small hamlets such as King Station, Stiles Corners, Dimmick's Corners, Emerson's Corners, and Mount McGregor.

Emerson's Corners was named for Broadstreet Emerson, who owned a tavern (built in 1790) that became the first seat of government in Wilton in 1818. A historic marker at the corner of Ballard and North Roads marks the site. In the late 1800s, a bottling plant distributed mineral water from the area, which was then known as Gurn Spring. The spring was closed in the early 1900s. The Gurn Spring Methodist Church (built in 1885), the South Wilton Church (built in 1854), and the Wiltonville Church (built in 1871) are still in existence but no longer operate as Methodist churches. The combined congregations now occupy the Trinity Methodist Church, on Ballard Road.

Duncan McGregor, a farmer in Wilton, bought the nearby mountain for back taxes. Rev. R.G. Adams, whose congregation often had meetings and church picnics there, named the mountain Mount McGregor.

Joseph Drexel and John Arkel bought land from Duncan McGregor with the intention of building a resort area that would rival Saratoga Springs. They built the Saratoga, Mount McGregor, and Lake George Railroad for transportation from Saratoga to the top of the mountain. The lovely Balmoral Hotel, one of a few that had electricity, was also built. A cabin built by Duncan McGregor was used by construction workers as a hotel while work proceeded. The following summer, Joseph Drexel heard that Gen. Ulysses S. Grant had terminal throat cancer. Drexel offered the cabin to the family so that the general could be more comfortable while completing his memoirs. Grant came to the cabin in June 1885. The Balmoral Hotel burned in 1897 and, with it, the dreams of a resort.

In 1911, the Metropolitan Life Insurance Company purchased land to build a tuberculosis sanatorium for its employees on Mount McGregor. The hospital became an economic boon to the people of Wilton, who were hired to work at the kitchens, laundry, and farms. Modern medicines had tuberculosis under control by the 1940s, and the hospital closed.

Gov. Thomas E. Dewey authorized the state of New York to purchase the property for the purpose of making it into a rest home for World War II veterans. Veterans took advantage of the walkways, game rooms, and fresh air. When the rest home closed, the New York State Department of Mental Hygiene took over the facility and cared for children until 1975, when they moved to a new home in Wilton. A minimum-security prison opened on the Mount McGregor property in 1976.

# *One*
# STILES CORNERS

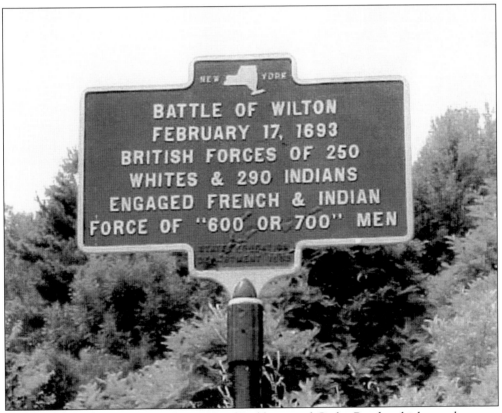

BATTLE OF WILTON
FEBRUARY 17, 1693
BRITISH FORCES OF 250
WHITES & 290 INDIANS
ENGAGED FRENCH & INDIAN
FORCE OF "600 OR 700" MEN

This historic marker stands on the corner of Parkhurst and Gailor Roads, which was the scene of the Battle of Wilton in February 1693. The English were under the command of Maj. Pieter Schuyler and fought a bloody three-day battle. The French left under cover of a fierce snowstorm and crossed the river to the north on an ice floe.

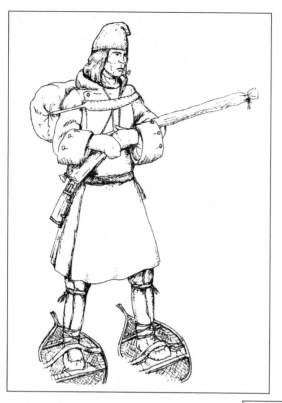

The French soldiers under the command of Nicolas de Mantet traveled the great distance from Canada on *racquetts* (snowshoes). They pulled the supplies for the long journey on sledges. They planned the surprise attacks on the English settlements of Schenectady and Fort Orange in revenge for the English attacks in previous years. (Illustration by Ralph Mitchard, courtesy of Bob Bearor.)

Count de Frontenac, governor of Canada, dispatched 100 soldiers and a large number of Canadian voyageurs from Montreal in January 1693. Mission Mohawk Indians joined the other French allies, the Abenakis, Algonkins, and Sokokis of Three Rivers, with orders to destroy the Mohawk castles at Fort Orange. They left Chambly and traveled 16 days to the area near Tribes Hill. The battle was short and bloody. They took 300 captives on their long journey home. (Illustration by George "Peskunck" Larrabee, courtesy of Bob Bearor.)

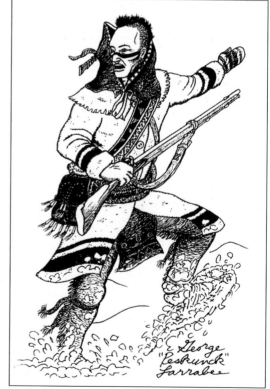

Ann Grey is one of the best-remembered women who enjoyed life in the Stiles Tavern. She was admired as a loving mother, homemaker, and teacher. She was a prominent community-minded citizen of Wilton. The Ann Grey Gallery at the Casino in Saratoga Springs is a tribute to her spirit.

The John Stiles family of Hopkinton, Rhode Island, settled here in 1773. The family brought fruit trees from Rhode Island and planted some of the first orchards in the area. John's son Reuben Stiles built the Stiles Tavern on the northeast corner of Parkhurst and Gailor Roads. The tavern was an important stagecoach stop. Town meetings were held here in 1839. The Stiles family occupied the house until 1926. (Photograph courtesy of Michael Noonan.)

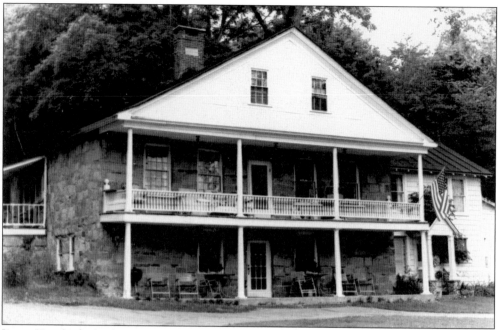

James King built this house in 1833 with stone quarried on Gailor Road. The walls are two feet thick. A ballroom occupied the top floor, and a dutch oven was on the first floor. Sebie Hodges operated the Singing Kettle Tea Room in the 1930s. Stiles Corners became known as King Station *c.* 1800.

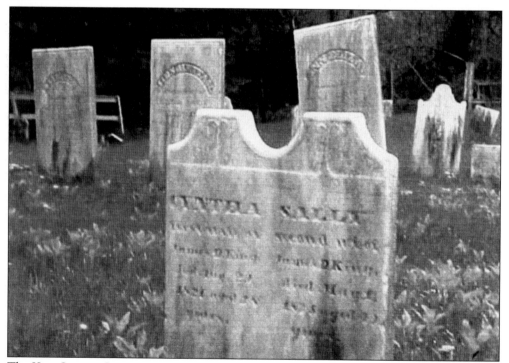

The King Station Cemetery is across the road from the old stone house. The cemetery is small and holds many original stones of the town's first citizens.

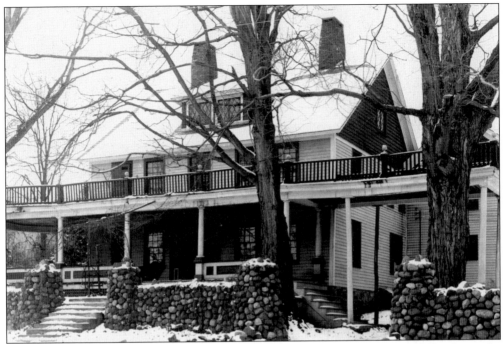

The old Maude King house, which once stood on Parkhurst Road, was destroyed by fire in the 1930s. The stone driveway pillars still mark the place. Jerome Bonaparte of the French royal family visited the home in 1907, and for many years after, the name Jerome was favored for the sons of the King family.

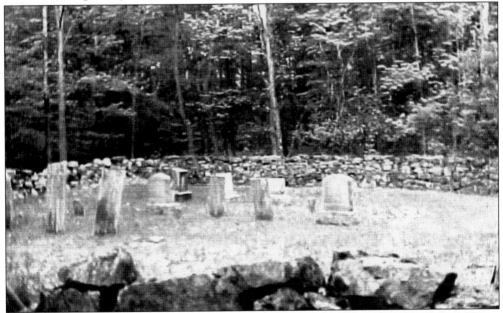

The Brisbin Cemetery stands on a hill across the road from the site of the Maude King house. A wonderful stone wall keeps the cemetery separate from the surrounding forest. The stones are all original to the time of the town's first settlers. Joseph Brisbin's stone is still legible, as are some of the King family stones.

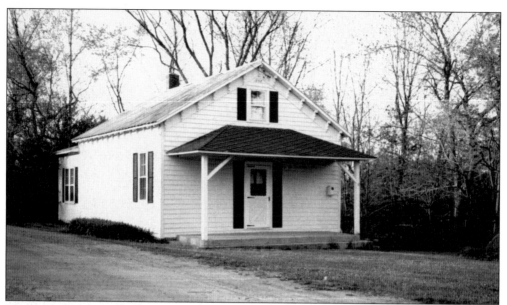

The King Station District No. 5 School was the last one-room school to be closed (in 1959). It remains in the same form as it was when used for a school. Two schoolteachers have occupied this building for more than 40 years, and the original globe is still in their living room. It was a favorite stop on the annual house tour a few years ago for some of the former students. Sebie Hodges, who lived in the old stone house, was a school trustee for many years.

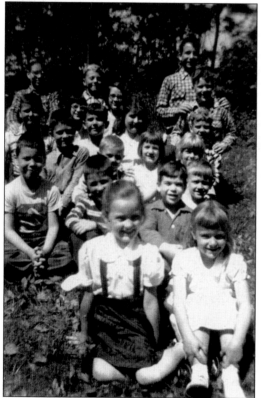

These children were part of the the Class of 1954. They are identified as Jeffrey Maier, Charles Slosick, John Maier, Ralph Foster, Judith Cline, Sandra Cline, Carl Hammond, Norman Hagadorn, Rick Ernst, Phyllis Ebert, Joseph Slosick, Lawrence Hagadorn, Clarence Burns, Linda Cline, Faye Kirk, Newman Wait, Lawrence Pratt, Richard Helenek, Molly Hammond, and Joanne Ernst.

14

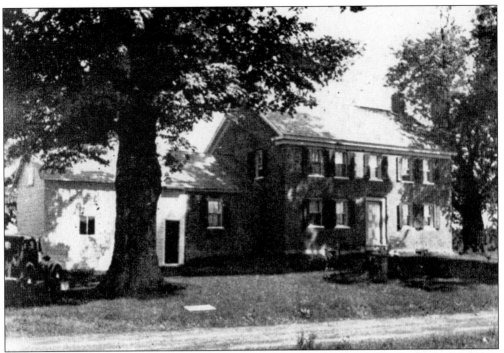

Stafford Carr of Rhode Island built this house in 1842 on Gailor Road. The bricks for the house were made at the Roods brick kiln, which was on a farm on what is now Northern Pines Road. Carr was a Baptist who donated land for the Brick Church and Cemetery around the corner on Northern Pines Road.

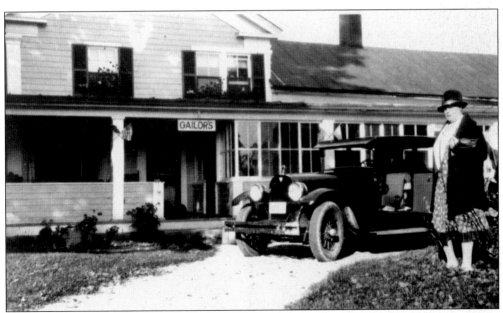

This house, also built by Stafford Carr, remained in the family until the early 1900s. It was sold and was operated as a tourist home. Its location, on the Saratoga–Glens Falls road, was an asset. Now privately owned, the house was renovated recently.

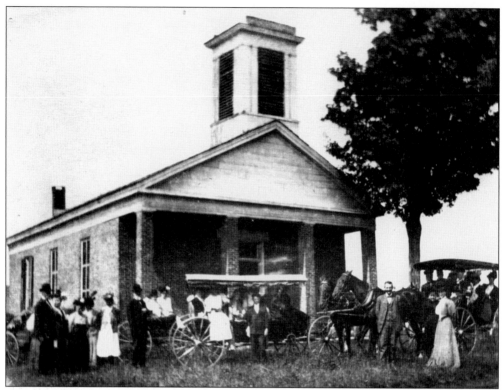

The Brick Church was built in 1854 at a cost of $1,500. Unused for a time and badly deteriorated, the building was dismantled by Allen B. Lockwood in 1935. The bell was placed in the town hall. After the town hall fire in 1973, the bell was put on display at the Wilton Heritage Society Museum.

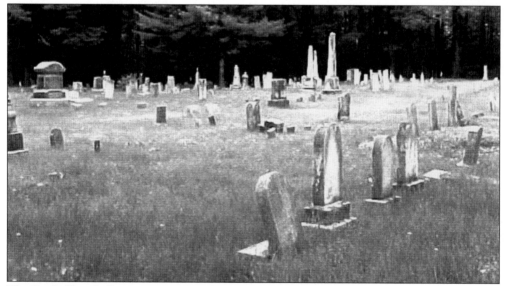

The Brick Church Cemetery is on Northern Pines Road. An iron fence separates the cemetery from the surrounding woods. Many old families are represented here. Stafford Carr, who donated the land, would be pleased with the appearance of this well-maintained cemetery.

*Two*

# WILTONVILLE

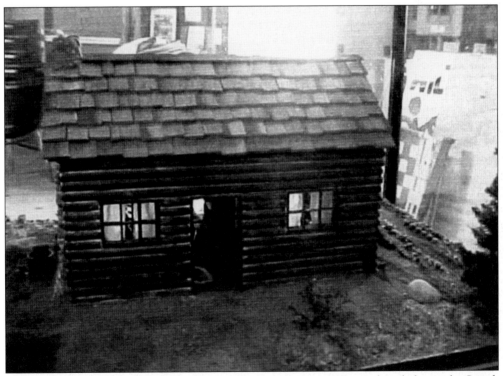

The Brisbin brothers came to Wilton before the Revolutionary War and settled near the Snook Kill on what is now Parkhurst Road. They built a sawmill and a log cabin, as depicted in this diorama made by former historian Lorraine Westcott. The display is a favorite of children visiting the Wilton Heritage Society Museum Farm Annex .

This rustic barn sits on the edge of the Woodard Road, which was once the main road to Jessup's Landing (Corinth). The farm across the road, built c. 1770, was known as the Harmon Perry home. The Perry family stayed here during the Revolutionary War because they were not considered a threat to the English.

Harry Woodard lived in the house just up the hill from Harmon Perry. The Woodards and the Perrys were connected by marriage. The house burned in the 1940s, but the maple trees are still visible (one tree and two stumps).

John Nichols bought the house on the northeast corner of Woodard and Nichols Roads. A Civil War veteran, he married Eleanor Loomis in his middle age and raised a family. He died in 1921 and is buried in the John Ellsworth Cemetery in Gurn Spring.

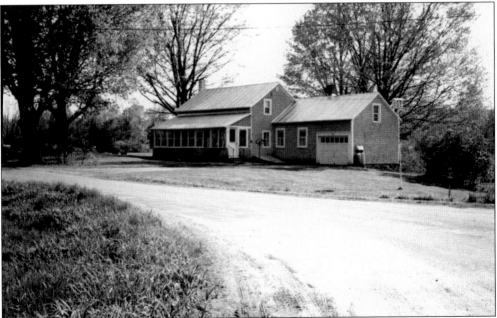

This house stands on land that was purchased from Obediah Green in 1830. Harry Woodard built the house on the southwest corner of Woodard and Nichols Road. The house is well structured, having huge hand-hewn beams in the cellar and a foundation of large stones.

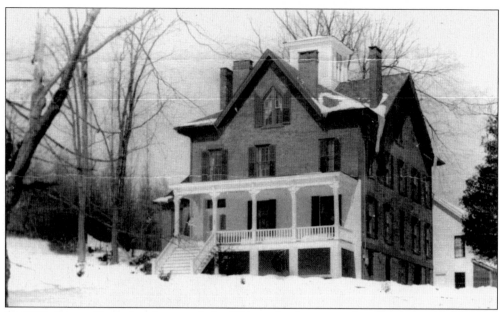

In 1859, Steven Fradenburgh opened the Wilton Academy as a boarding school of superior facilities. He operated the school for only two years. The building, occasionally used as a school throughout the years, was destroyed in a tragic fire on January 2, 1970.

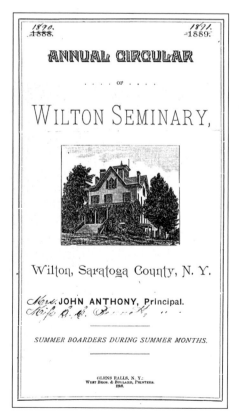

The Wilton Seminary brochure states, "Wilton is a quiet little village situated at the southern base of Mt. McGregor, seven miles north of Saratoga, on the line of Mount McGregor Railroad. Being a small village, it does not present the temptations usually found in large towns. No intoxicating liquor is sold in this town, and no places of questionable amusement are open to ensnare the young."

Lucy Allen and her sister Bessie Gailor conducted a private school in their private home, formerly the Old Wilton Academy. The last class was taught in 1925. This picture was taken on the last day of school. The students include James Parker, Earl Fowler, Virginia Washburn, Ann Liddell, Charles Van Rensselaer, Jane Washburn, Loren Liddell, and Harold Parker.

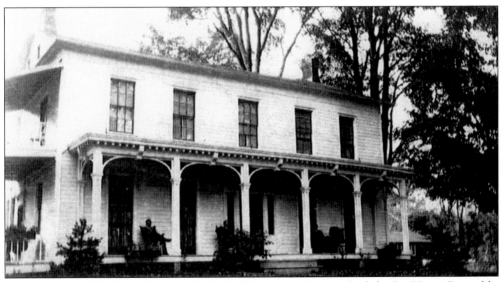

This house is on Parkhurst Road at the foot of Mount McGregor. Built by Dr. Henry Reynolds, it was later owned by Dr. Marshall, who donated the land across the road for the Methodist-Episcopal church in Wilton. Several later owners used the house for guests, but it is now a private residence.

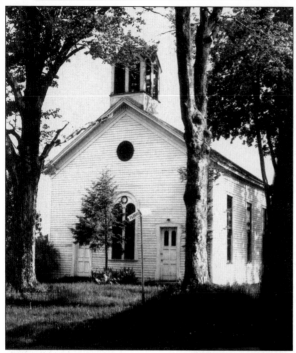

The Methodist-Episcopal church in Wiltonville was erected in 1871 and served the community until the early 1960s, when the congregation joined the Gurn Spring Methodist Church for worship. The Wilton Heritage Society purchased the building and uses it as a meetinghouse and historical museum. Fund-raising events are the Strawberry Social and the Apple Pie Social. The society also offers an annual historic house tour.

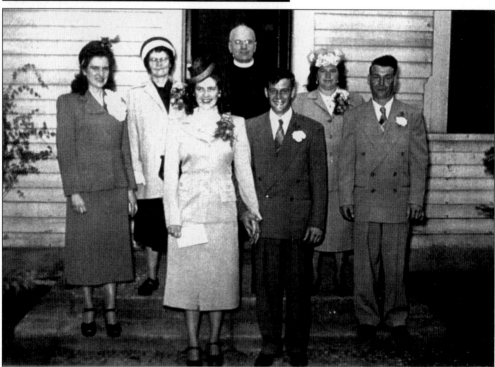

June Abbey and William Parker were married in the Wilton Methodist Church in 1949. The best man was the groom's brother Norman Parker, and the matron of honor was the bride's sister Jayne Holz. The mother of the bride was Blanch Abbey, and the mother of the groom, Edna Parker. All are pictured on the church steps.

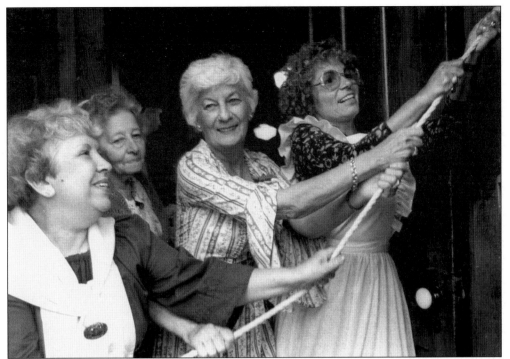

These joyful bell ringers are celebrating the repair of the bell tower at the Wilton Heritage Society. From left to right are Lorraine Westcott, Jennie Blodgett, Regina Van Rensselaer, and Karen Campola. The bell was rung for fires and for special occasions, such as the end of World War II.

The Wilton Heritage Society Museum Farm Annex opened on October 11, 1998, through the cooperation of the Wilton Heritage Museum Commission and the Wilton business community. The tireless effort of Lorraine Westcott, former Wilton Heritage Society president and longtime town historian made this happen. The Farm Annex and the Heritage Museum are educating the public about the history of the area.

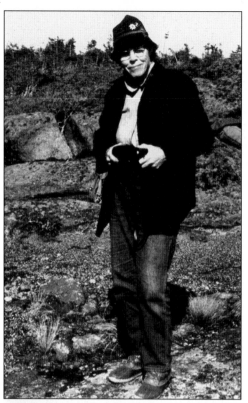

Dr. Orra Phelps lived in the old French home on Parkhurst Road for many years. She was a physician and a retired U.S. Navy lieutenant commander. She taught geology and was a well-respected naturalist and botanist. As a member of the Adirondack Mountain Club, she climbed all 46 peaks many times. She is pictured in 1967 on Algonquin Mountain.

Built *c.* 1800 for Col. Windsor B. French, this attractive home on Parkhurst Road has a long and varied history. Indian artifacts have been found in the fields. Parkhurst Road follows the early Native American trail along the base of the Palmertown range. The Phelps family purchased the property *c.* 1918 and lived there for some 50 years.

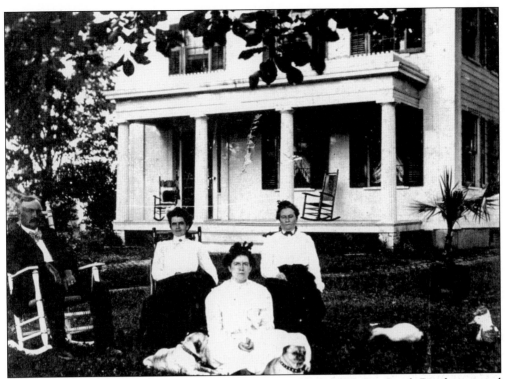

This old home at the hub of old Wilton was built in 1804. In 1903, Dr. Smith Roods occupied the house. His family is pictured on the lawn. Still privately owned, it stands as a remembrance of Wilton's past on the corner of Northern Pines and Wilton–Gansevoort Roads.

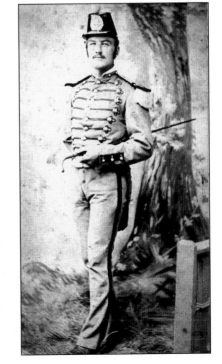

Dr. Smith Roods was a physician for many years in Wilton. He drove his horse and buggy to care for the sick and charged $1 for a house call. He is pictured in his uniform as a member of the Wilton Cornet Band, which met at the old Union Meeting House at Emerson's Corners.

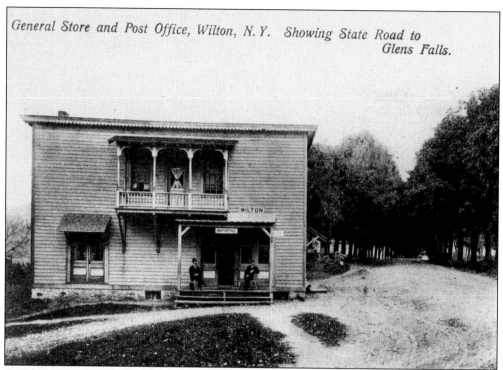

*General Store and Post Office, Wilton, N.Y. Showing State Road to Glens Falls.*

In the early 1900s, Charles Van Rensselaer's store and post office stood on the northwest corner of Old Route 9 (Northern Pines Road) and Wilton–Gansevoort road. In the background is the Clement house, which is still occupied. The street, with the beautiful maple trees, was at that time the main road between Saratoga and Glens Falls. The store was destroyed by fire.

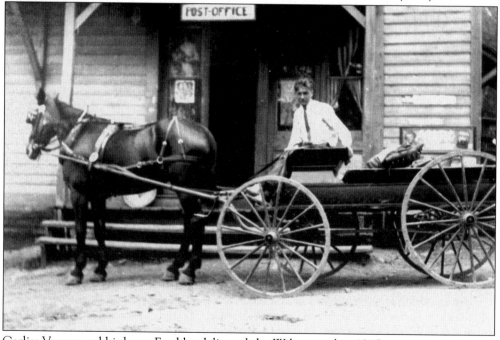

Corliss Varney and his horse Freckles delivered the Wilton mail in 1915.

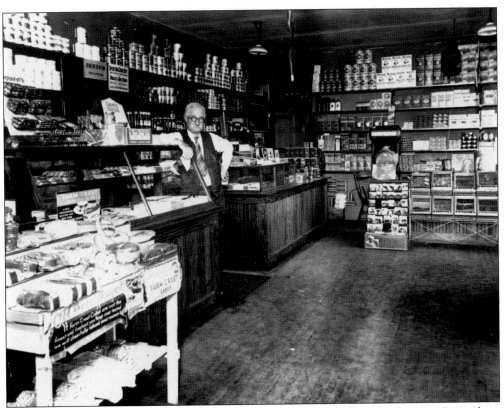

This is the interior of the Charles Van Rensselaer store *c.* 1920. Charles Van Rensselaer, pictured at his counter, was the town supervisor from 1919 to 1925 and from 1928 to 1931. He started the store in 1893 and served as postmaster from 1904 to 1917. He was schoolteacher in his time and operated a truck and fruit farm.

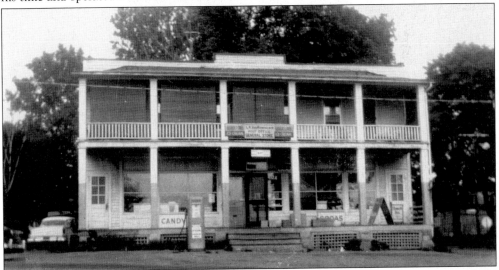

The new Van Rensselaer store was built across the road and was on the northeast corner of Old Route 9 and Wilton–Gansevoort road. The store porch steps were the hub of social life for Wilton's youth. This store was also destroyed by fire

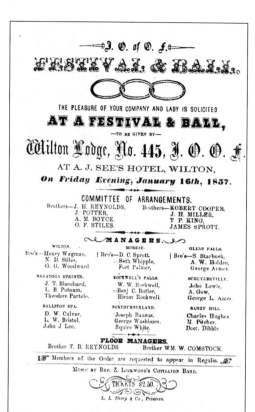

This is a record of the Wilton Lodge No. 445, which met at A.J. See's Wilton Hotel (now called the Stage Coach on Northern Pines Road).

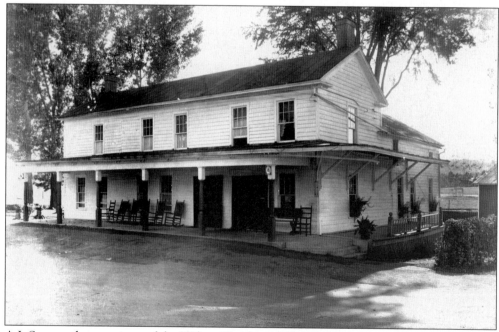

A.J. See was the proprietor of the Wilton Hotel in 1858. Mike Ryan owned the hotel from the beginning of the 20th century until his death in 1939. It has since changed ownership many times but is best known as the Stage Coach on Northern Pines Road.

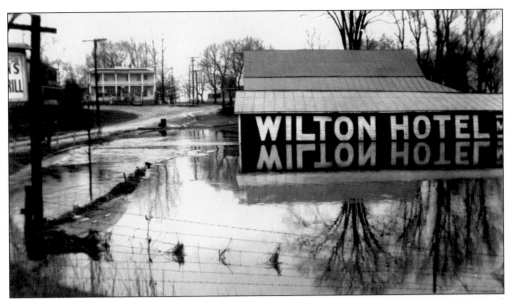

Floodwaters covered Route 9 in Wilton c. 1948. The hay had to be removed from Ryan's Hotel barn. The Van Rensselaer store is in the background.

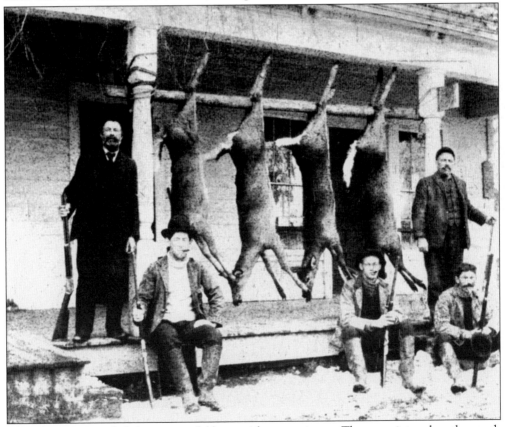

These hunters recorded their successful hunt with a rare picture. They are pictured on the porch of Ryan's Hotel. Mike Ryan, the owner, is standing at the left.

Tabor Reynolds built this house at the foot of Mount McGregor. It was later the Charles C. Van Rensselaer home. Jennie Lincoln Van Rensselaer operated the home as the McGregor Lodge. She was the wife of Charles C. Van Rensselaer and the mother of Leslie Van Rensselaer, successor of the business.

This early photograph of William Green and his companion was taken at the bottom of the Mount McGregor road. William Green was later active in community affairs and was a longtime employee on Mount McGregor.

The Wilton Hall was on the main east–west street of Wilton in the early 1900s. It had a nice dance floor and was the community center for entertainment. The hall burned in the 1920s.

# VAUDEVILLE

**WILTON HALL**                    Aug. 30, 1902

PRESENTED BY:

Mrs. H. B. Walmsley, Miss G. S. M. Walmsley, Miss Daisy Kynersley, Miss C. Gratia Allen, Mr. Stanley Bush, Mr. Harry Allen, Mr. S. P. Walmsley, Jr., Master Latham Allen and Miss Mary Ellen Allen.

**H. B. WALMSLEY, Manager.**

TABLEAU..................William McKinley
TABLEAU..................Afternoon Tea
SONG.....................Military Man
RECITATION...............The Dumb Orator
TABLEAU..................Love's Awakening
DANCE....................The Dance of the Seasons
TABLEAU.................."The Little Corporal."
TABLEAU..................Emperor Napoleon
SONG.....................Nursery Rhymes
TABLEAU.................." A Col. of Volunteers."
TABLEAU..................In the Phillipines
SONG....................."Mr. Dooley."
TABLEAU..................Emperor of Germany

Music by Mrs. J. W. Wicks.

TABLEAU..................An Old Fashion Garden
TABLEAU..................Romeo add Juliet
TABLEAU..................A Grecian Maid

Music by Mrs. J. W. Wicks.

SONG....................."Reuben and the Maid."
NEGRO SONG..............."Mammy's Little Boy."
DANCE....................Amusement of an Emperor

Music by Mrs. J. W. Wicks.

SONG.....................Plantation Song

CAKE WALK.

Ice Cream and Cake served after the performance 15 cents

This photograph shows the scene of the Wilton Hall fire. The building was located on the northwest corner of the present Route 9 and Parkhurst Road, across from People's Automotive. Route 9 was built in the 1930s. The house in the center was the first home of Howard and Madeline Petteys.

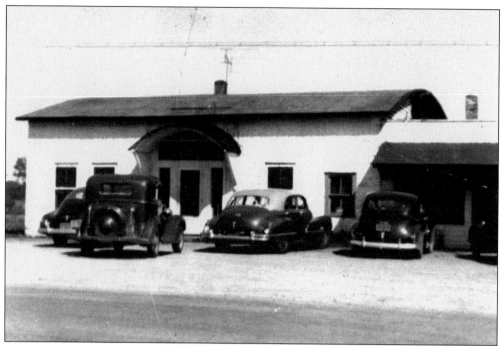

The Paradise was a popular nightspot in the 1940s. It was located on Old Route 9 (Northern Pines Road) in the building later occupied by Arnold's Auction Barn and then by the Wilton Post Office substation.

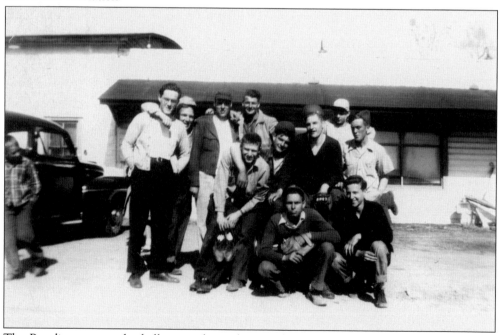

The Paradise sponsored a ball team, shown here in front of that establishment. From left to right are the following: (front row) Bill Walker and Gilbert Pratt; (middle row) "Bunny" Doescher, Jim Varney, Gregory Green, and Hubie Ellithorpe; (back row) Fred Guyer, Larry Parker, Kittner Green, Norm Parker, and Frank Winslow.

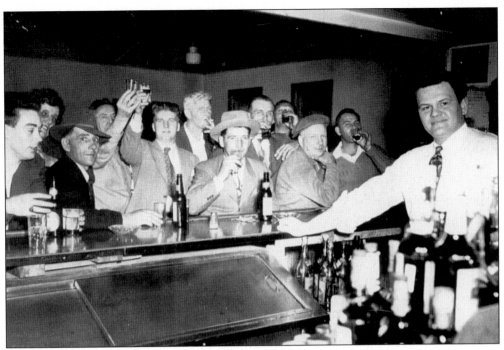

A wedding reception at the Paradise was always a lively occasion.

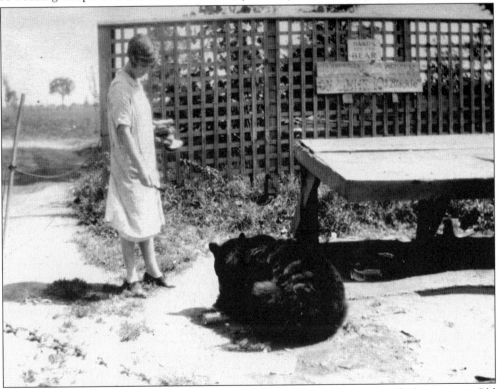

Lillian Worth feeds Blackie the bear, the featured attraction at James Angel's business on Old Route 9. The building later housed Arnold's Auction Barn.

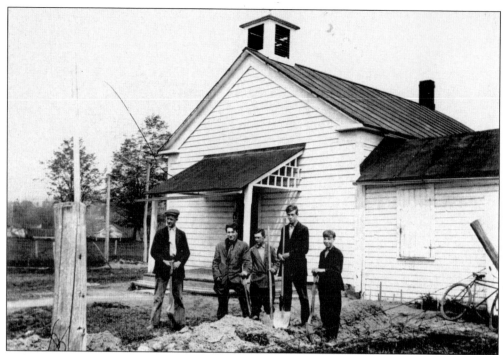

Wiltonville District No. 4 School was on the Gansevoort–Wilton road. From left to right are students Charles Hodges, Wallace Orton, Charles Ketchum, Wilder Nichols, and Willy Cisco. The building is now a private home.

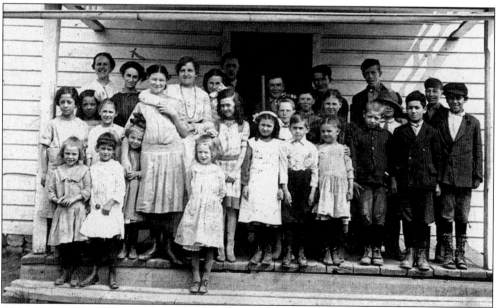

This photograph of a school group on the porch of the Wiltonville District No. 4 School was taken c. 1911. Among the children pictured are Curt Hodges, Angie Deyoe, Anna Mott, Wilder Nichols, Naomi and Wally Orton, Helen Osborn, Elizabeth and Rudolph Harder, Emile Varney, Florence Clements, Sophie and Joe Gennell, Bill Cisco, and Maude Putnam. The teacher was Mina Angel.

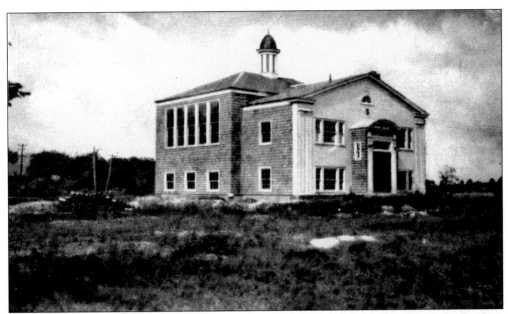

The Wiltonville District No. 4 School was erected in 1925 just east of the original school. A new wing was added as it was needed by a larger population. In 1966, a fire destroyed the school except for the new wing, which was the gymnasium. The Board of Cooperative Services used this building for many years.

H. Whitney Butterfield was the first principal of Ballard Elementary School, which opened in July 1968. He retired in 1997 after a 35-year career in education.

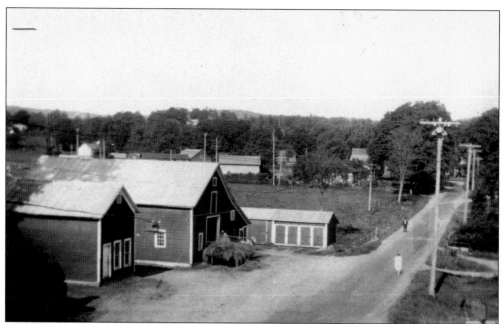

The main east–west street in downtown Wilton connected all the elements needed for a community: the Wilton Methodist Church, the Wilton Hall, a blacksmith shop, a general store, the Wiltonville District No. 4 School, and doctor's offices. This 1929 picture shows the Wilton Hotel, an icehouse, a hay barn, and a wagon shed.

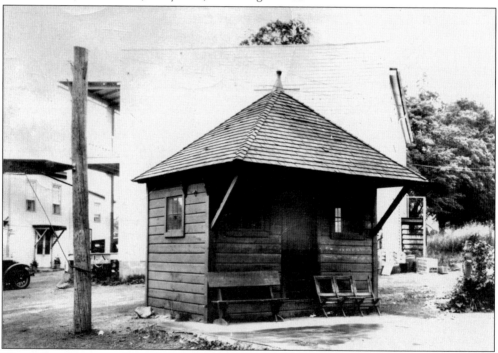

The trolley station was located near the Van Rensselaer store. In the early 1900s, many people used the Hudson Valley Trolley to travel between Saratoga and Glens Falls. The station was dismantled in 1926, when the line was abandoned.

The Snook Kill runs through the center of Wiltonville, and the bridge was necessary to travel the main street. In the early 1930s, Route 9 was built in the north–south direction, dividing the community in half. When the bridge was taken out in the 1990s, Wilton lost the pedestrian route between the two halves and the separation became complete.

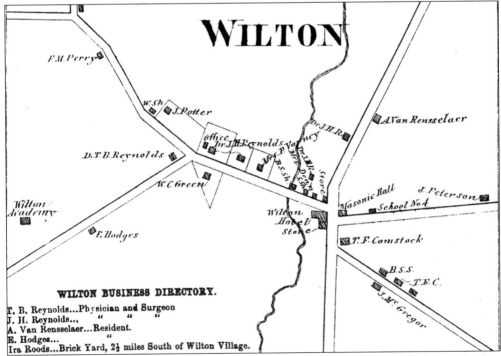

The 1866 Beers map shows a prosperous business section in Wilton's north sector near the foot of Mount McGregor.

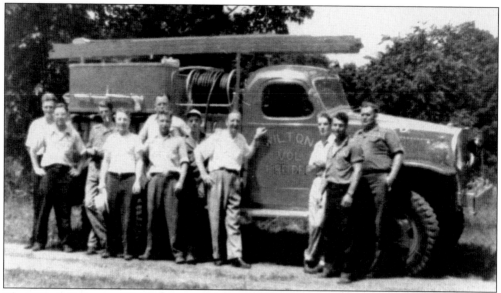

The Wilton Volunteer Fire Company was formed in 1947. This is a picture of the first fire truck, a 1944 International. From left to right are the following: (front row) Ken Petteys, Dallas Petteys, Curt Petteys, Walt Duncan, and Norman Parker; (back row) Larry Parker, Ray Fowler, Richard Woodcock, James Parker, Elwin Miner, and Earl Fowler.

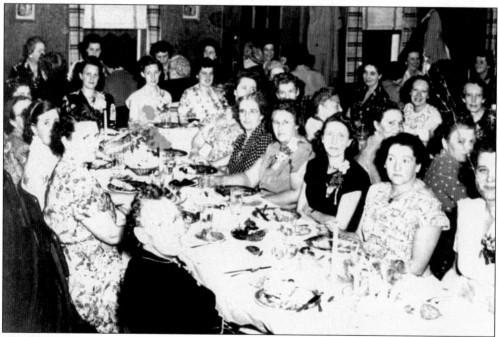

The Wilton Volunteer Fire Company Auxiliary had a banquet at Pine Inn on the new Route 9 on May 16, 1950. Those attending included Estella Phelps, Maria Lindstrom, Lillian Worth, Ethel Kloss, Marge Henning, Madeline Petteys, Mildred Petel, Jane Mattfeld, Mildred Ellithorpe, Lillian Huntley, Margaret Woodard, Madaline Nagel, Helen Spafford, Margaret Morgan, Catherine Engel, Jean Van Rensselaer, Natalie Ellithorpe, Florence Ernst, Helen Duncan, and Mae Smith.

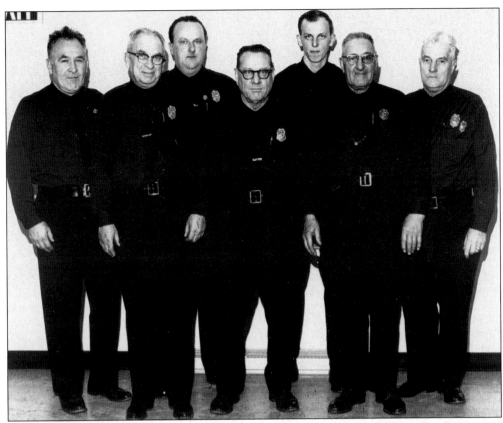

These Wilton volunteer firemen visited the Ballard Elementary School during Fire Prevention Week in 1969. From left to right are John Petel, Earl Weideman, Leon "Sonny" Hammond, Harry Burns, Robert Helenek, Ernest Woods, and Elwin Miner.

The first Wilton firehouse was located near the corner of Old Route 9 and the Gansevoort–Wilton road. The firehouse was expanded as more equipment was acquired.

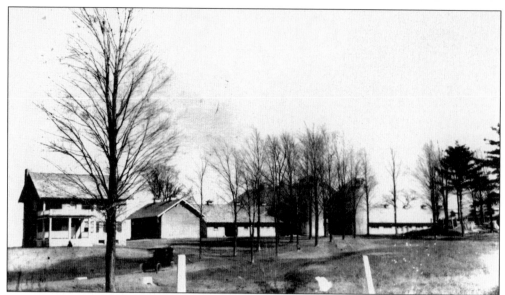

The Metropolitan Insurance Company farm was built on the site of Orchard Hill, Cyrus Perry's home. Cyrus Perry was married to Waity Comstock, joining two old Wilton families. The farm supplied all the food for the sanatorium on Mount McGregor.

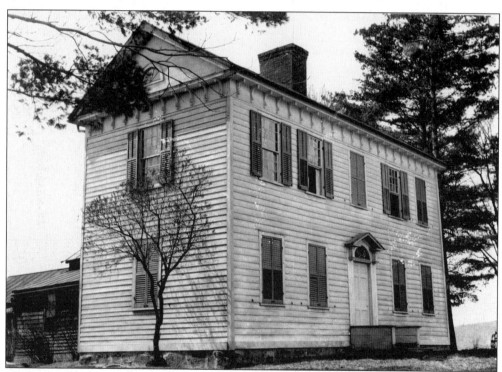

The tenant house of Metropolitan Farm No. 2 was home to the employees of the Metropolitan Insurance Company. The house once stood on Ballard Road at the site of the state police station. It was moved to the corner of Ballard and Northern Pines Roads.

The Metropolitan Insurance Company farm provided housing for the employees. The boardinghouse provided sleeping rooms and meals for the men who worked on the farm. The farm at one time employed most of Wilton's young men

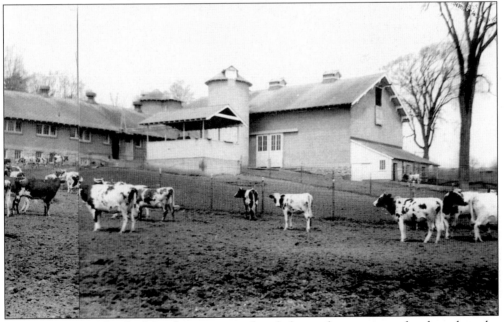

The prizewinning herd of Ayrshire cows produced the perfect nutrients for the tubercular patients of the Metropolitan Sanatorium.

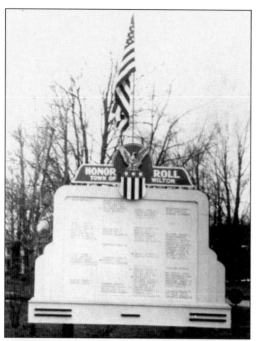

The World War II honor roll once stood on the corner of Route 9 and Mountain Lane (Parkhurst Road) near People's Automotive. It was moved to the site of the old town hall in Gurn Spring, where it was accidentally destroyed by a snowplow.

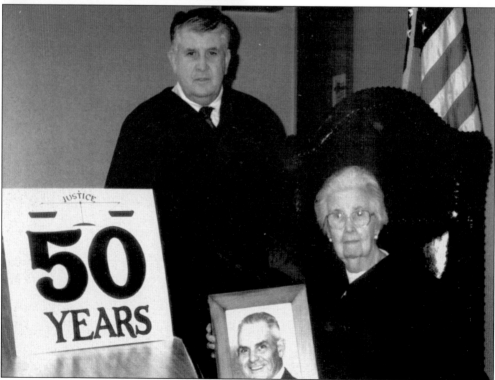

The Worth family has served Wilton as town justices for more than 50 years. Wesley J. Worth (pictured in the framed photograph) was justice from 1945 until his death in 1973. His widow, Lillian Worth, was justice from 1973 to 1976 and was replaced by her son Gerald Worth, who serves in that office today.

The Hill Crest offered country breakfasts and delicious home-cooked meals to guests enjoying the refreshing rural scenery.

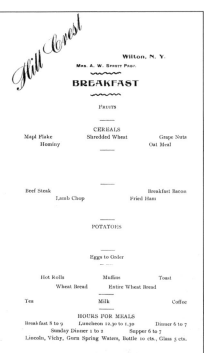

Hill Crest

Wilton, N. Y.

MRS. A. W. SPROTT PROP.

## BREAKFAST

FRUITS

CEREALS

Mapl Flake     Shredded Wheat     Grape Nuts

Hominy     Oat Meal

Beef Steak     Breakfast Bacon

Lamb Chop     Fried Ham

POTATOES

Eggs to Order

Hot Rolls     Muffins     Toast

Wheat Bread     Entire Wheat Bread

Tea     Milk     Coffee

HOURS FOR MEALS

Breakfast 8 to 9     Luncheon 12.30 to 1.30     Dinner 6 to 7

Sunday Dinner 1 to 2     Supper 6 to 7

Lincoln, Vichy, Gurn Spring Waters, Bottle 10 cts., Glass 5 cts.

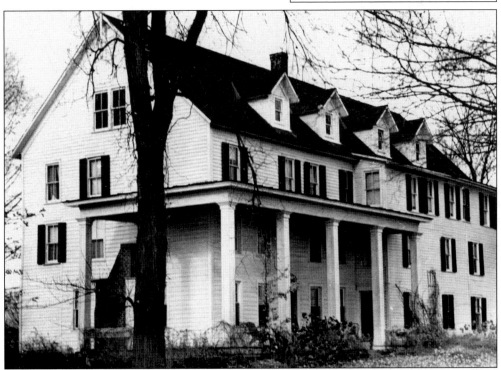

Hill Crest was located atop a gently rising hill on the Wilton–Gansevoort road. The hotel had a nearby station on the trolley line. It offered croquet, tennis courts, and a big apple orchard (across the road). Adelaide Sprott and her son Walter operated the establishment. A huge fire destroyed the hotel in 1964.

43

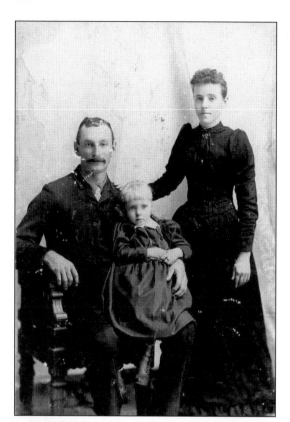

Dan and Minnie Deyoe lived in the house on Mountain Lane (Parkhurst Road) across from the Wiltonville Methodist Church. They had two daughters—Angeline and Mable. This picture shows the couple with Mable.

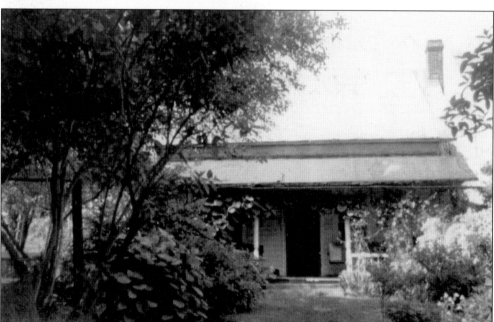

The Deyoe home was just east of Charles C. Van Rensselaer's home. When Angeline Deyoe married Ernest Woods, she continued to live in this house. She taught Sunday school at the Wiltonville Methodist Church.

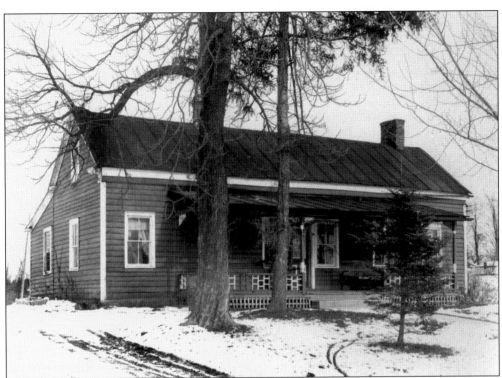

Dallas Varney and his wife, Jessie, lived in this home on Mountain Lane (Parkhurst Road). The house was between the Deyoe home and the old Wilton Hall, which was destroyed by fire in the 1920s. Jessie lived with the Hodges on their farm in Wilton, which was on the upper road (Parkhurst Road) between "Doc" Lincoln's house, on the corner of Lower Road (Ernst Road), and the Wiltonville Methodist Church.

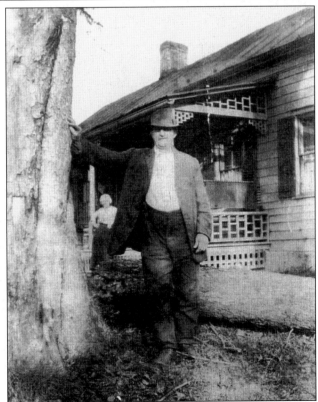

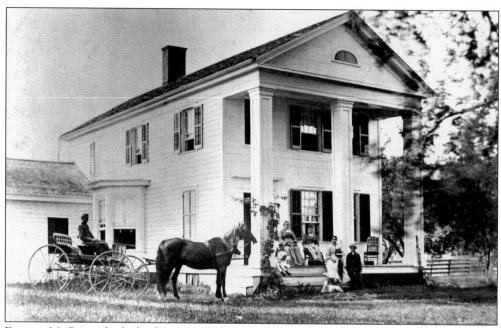

Duncan McGregor built this home c. 1830. He was in the lumber business and decided to clear the mountain behind his house. He built a road to the summit and a small hotel. The hotel soon became a very popular weekend destination. The mountain was named after McGregor. The Myers family bought this house from Duncan McGregor. Shown are members of the Myers family in their Sunday best.

F. Donald Myers lived in the house during his long educational career. He retired as superintendent of the Board of Cooperative Education Services (BOCES). The Myers Education Center, on Henning Road in Saratoga, was named in his honor. His love for his farm was well known in the community.

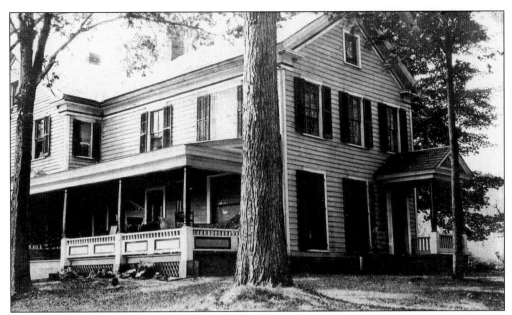

The Bush farm, known as the Gables, was located on Old Route 9. This picture was taken in 1912. The Myers family now owns the property. This beautiful old house still stands here, with Mount McGregor in the background.

Charlotte "Lottie" Bush wrote her journal of pleasures and chores of farm life in 1912 and 1913. Her journal was published as *Saratoga Diary*.

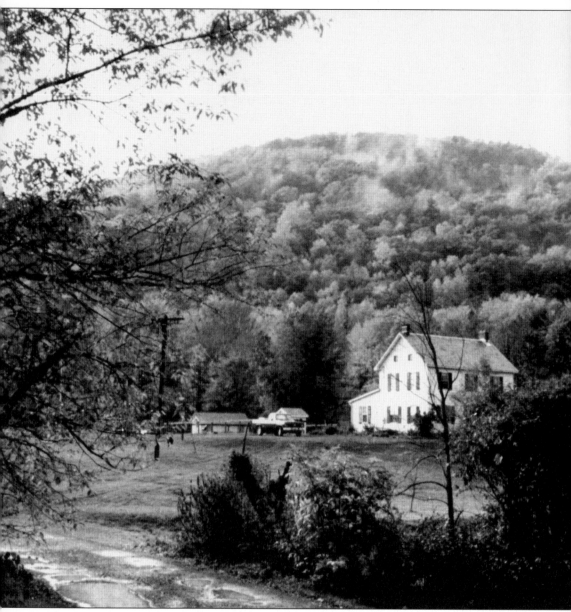

Joseph Henry built the first home on this site just below the Lookout on Mount McGregor. After the original house burned, the Henrys built this fine place. Orchards and vineyards once abounded on these lands.

# *Three*
# EMERSON'S CORNERS

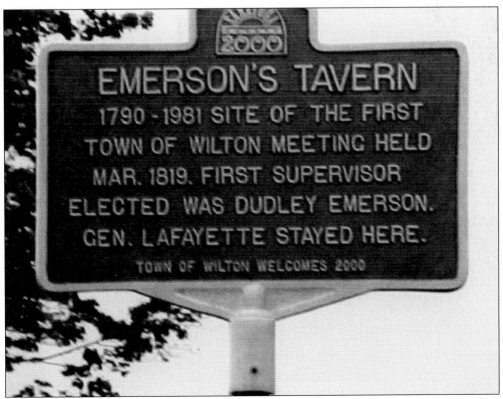

A historic marker stands at the corner of Ballard and North Roads, the site of the Ballard Tavern. The Wilton Welcomes 2000 committee received a grant from Saratoga County to place this marker.

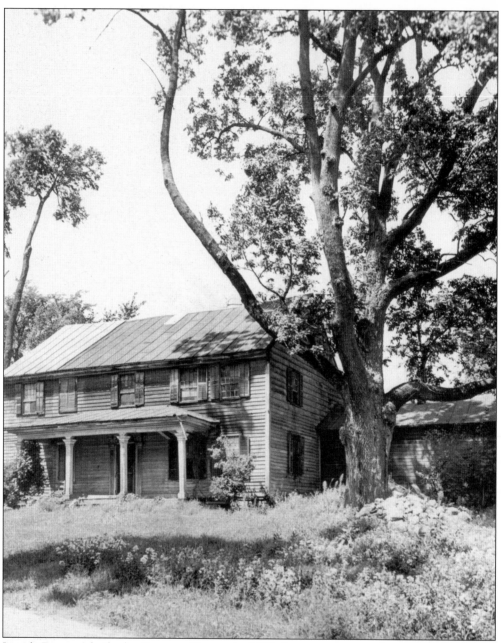

Joseph Emerson built the Emerson Tavern in 1790. It was a stagecoach stop and, in March 1819, was the location of the first town meeting. It remained in the Emerson family until it was burned by the order of the town in 1981. The door knocker was salvaged and may be seen at the Wilton Heritage Museum, on Parkhurst Road.

The last resident of the Emerson Tavern was Lyndes Emerson, who was born in the house and lived most of his life there. In his older years, Emerson went to live elsewhere because of ill health. The house deteriorated over a period of time until the town declared that it was a safety hazard and ordered its destruction.

A beautiful park used to be in Gurn Spring at today's junction of Ballard, Traver, and North Roads. The schoolchildren would go to this park in June for a picnic and games. The local people would make their lemonade from the waters of the mineral springs. The sheds on the right were known as Emerson's Horse Sheds. The town later used these sheds for storage.

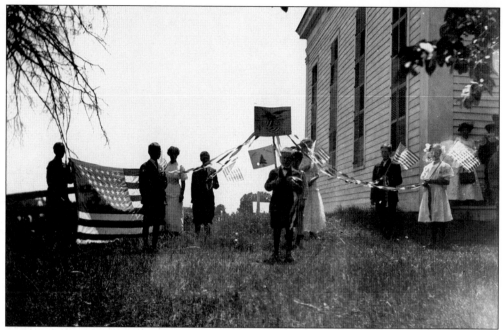

This photograph was taken during an Arbor Day celebration.

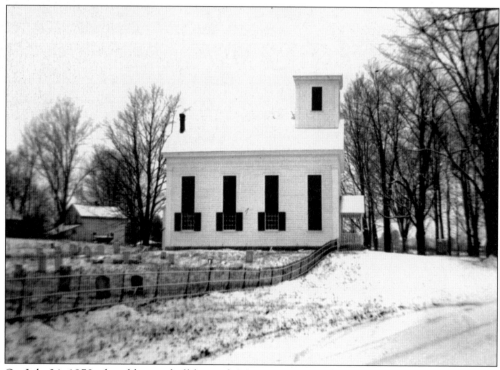

On July 24, 1973, the old town hall burned. Many town records were lost. In this photograph, the World War II sign listing Wilton military personnel can be seen. It succumbed to the snowplow sometime before the fire. Originally, the building was the Union Meeting House (built in 1805).

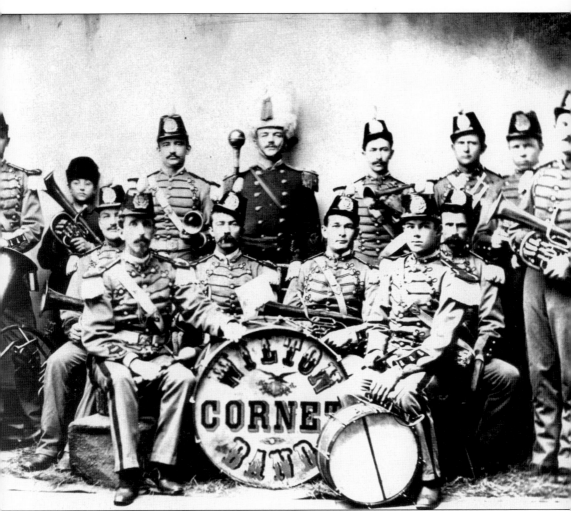

Some young men of the town organized the Wilton Cornet Band. They had permission to use the Union Meeting House, which was a nondenominational church in Kent. They were involved in a controversy about their disrespectful behavior. According to church records, the charges were that they "mocked prayers, Amens, Hallelujahs, spit tobacco juice on carpets and mistreated the sexton."

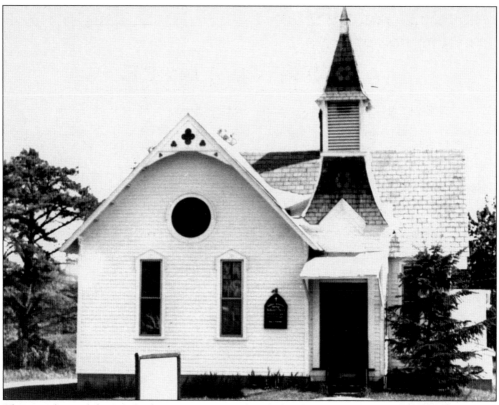

The members of the Methodist congregation decided to leave the Union Meeting House and build their own church in 1885. With the cooperation of the South Wilton Church, the Wiltonville Church, and gifts of money from people in the area, the church was completed in five months and was clear of debt. The tradesmen donated labor and material. The Methodists were pleased to have control over their church.

Pastor Robert B. Leslie and his wife were in service of the church in 1902 and 1903.

54

YOURSELF AND LADIES ARE
INVITED TO ATTEND A

# PRIVATE DANCE

TO BE GIVEN AT GURN SPRING HOTEL.

Thursday Evening,  -  January, 21, '97

COMMITTEE:

| | | | |
|---|---|---|---|
| J. H. MABBETT, | Saratoga | G. H. PRATT, | Wilton |
| J. W. HOWE, | " | JOHN WASHBURN, | " |
| M. G. ANNIS, | " | ALLIE MALLERY, | Corinth |
| G. H. ELLSWORTH, | " | RICHARD DENTON, | So. Glens Falls |
| SMITH TUBBS, | " | CHARLES WHITE, | " " |
| WM. SCHERMERHORN, | Wilton | SCOTT W. HOWE, | Fortsville |
| R. P. SCHERMERHORN, | " | WM. WASHBURN, | " |
| JOHN MYERS, | " | WM. PETTIT, | Gansevoort |

FLOOR MANAGERS:

H. M. LINCOLN,  -  -  -  F. D. ROADS.

TICKETS, ONE DOLLAR.            MUSIC BY LOCKWOOD'S ORCHE·

JOHN ELLSWORTH, PROPRIETOR

The Gurn Spring Hotel was the center of entertainment in the early 1900s. Emerson's Corners was known as Gurn Spring after the spring water became popular *c.* 1920.

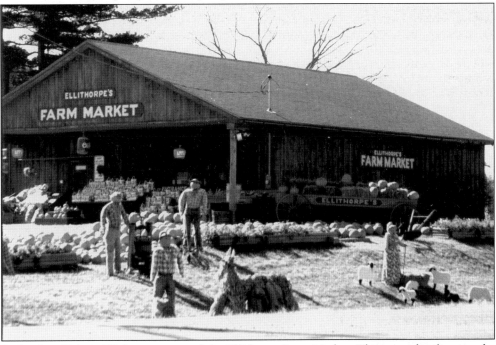

Richard and Marie Ellithorpe operated the Ellithorpe Farm Market. This was a familiar stop for many local people for several years. The pumpkin people were always an attraction, as well as seasonal products and fresh produce. The building was on the corner of Ballard and Traver Roads. It was demolished after a bank bought the property.

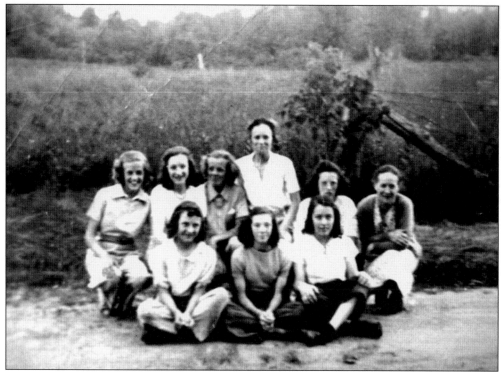

The first Girl Scout troop in the town of Wilton was Troop 8 of the Saratoga Council. Meetings were held in the old town hall at Gurn Spring. From left to right are the following: (front row) Marcella Petteys, Viola Craw, and Viola Woodruff; (back row) Margaret Ellithorpe, Virginia Petteys, Beatrice Ellithorpe, Marion Spires, Vivian Woodruff, and leader Violetta Woodruff (wife of Leslie Woodruff). Elizabeth Emerson took this photograph *c.* 1940.

Donald and Natalie Ellithorpe owned this home for many years. Donald Ellithorpe raised fresh vegetables, which he sold at the stand on the corner of Ballard and Traver Roads and also to restaurants, stores, and special customers. When he retired, he sold the property to his nephew Richard Ellithorpe.

56

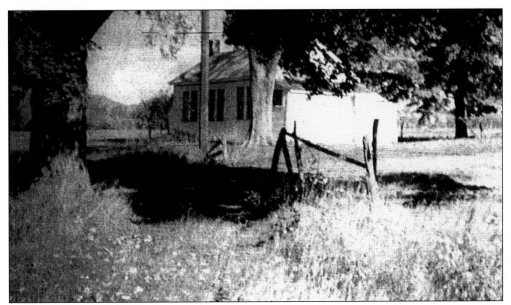

Pictured is the District No. 7 School, a one-room school on Gurn Spring Road. After being converted to a residence, it burned in the early 1980s. This road became a dead-end street when the Northway was built. The Stewart's store was built on the site.

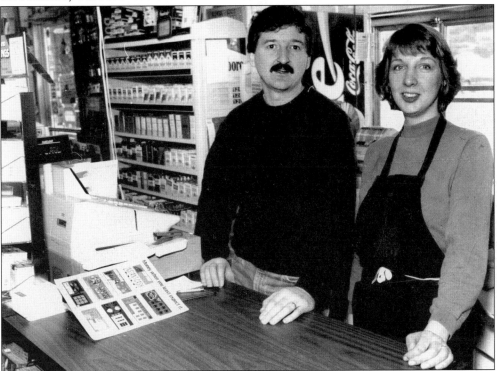

Ernie's Grocery has been serving the Gurn Spring and Wilton communities for more than 30 years. Ernie and Doris Fuller started the store in their living room and later expanded it. When Ernie retired, he sold the business to his son Darryl and wife, Kathy Fuller, who still operate it.

John and Sherrod Chase, trappers and sheep raisers, are pictured *c.* 1910. The house on Gurn Spring Road was built *c.* 1845 by George Shurter, who was an uncle of the Chase brothers. Ownership passed down to Oscar Johanson and later to Norman and Carla Brown.

Jennie Chamberlain lived in the former Chase house until she married William Betts. Afterward the couple lived in what was the older part of Ernie's Grocery.

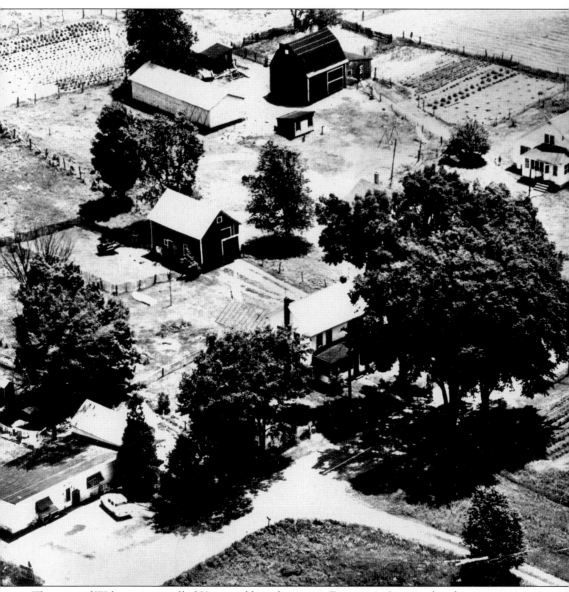

This part of Wilton, once called Kent and later known as Emerson's Corners, has for many years been named Gurn Spring. In this late-1950s photograph, the house in center foreground is the Brackett place, where Sen. Edgar T. Brackett was born. Brackett founded the Adirondack Trust Company and the McGregor Golf Links. Ernie's Grocery is in the lower left corner.

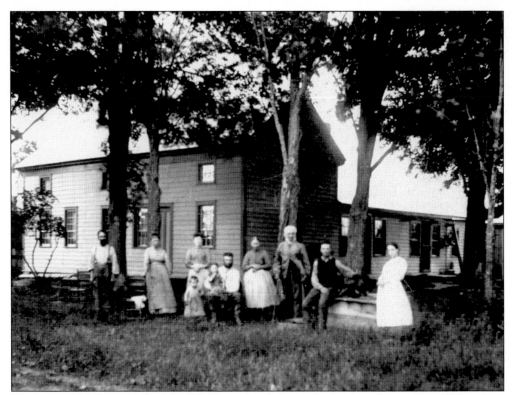

This is an 1891 photograph of the Washburn family home, located on the northern Wilton line bordering Moreau Township on Washburn Road, which was named for the family. From left to right are Dave Ellison, a hired man; Ann, a hired woman; Nettie and John Washburn, with their son Hiram Ernest, and daughter, Maude; Nettie and Hiram Washburn; Fred Lewis, a hired man; and Allie Farlow, a schoolteacher who boarded with the Washburns.

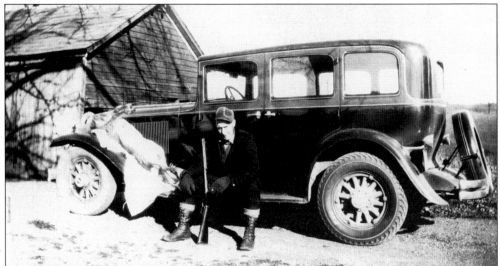

Hiram Washburn (1890–1955) was a well-known sportsman of the area. This 1930 photograph shows him sitting on the running board of his Hupmobile after a successful hunt at Cedar River Flow, Indian Lake.

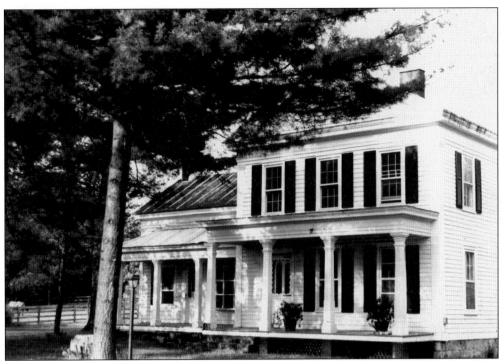

Sobieski Taylor, Wilton resident of the late 1800s, is shown below with his three granddaughters, from left to right, Alberta, Louise, and Mildred Beebe, on the porch of their home. The house was located at the corner of Dimmick and Ballard Roads. The girls' mother, Marcia Taylor Beebe, taught school at Gurn Spring in the 1930s. In later years, Alberta was town historian and Louise's husband, Frank Perry, was town supervisor.

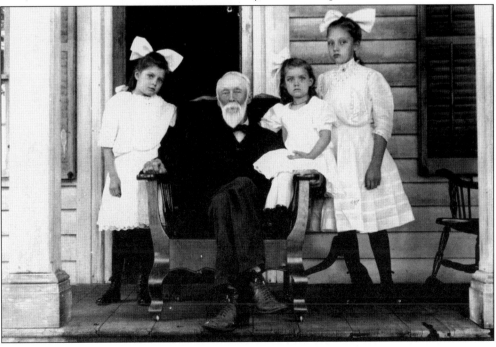

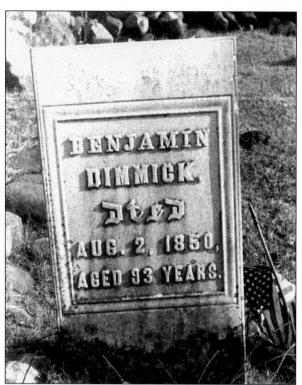

Benjamin Dimmick was a veteran of the Revolutionary War. In May 1775, he enlisted in Col. Israel Putnam's 3rd Connecticut Regiment. He rose from the rank of ensign to lieutenant and was discharged in 1783.

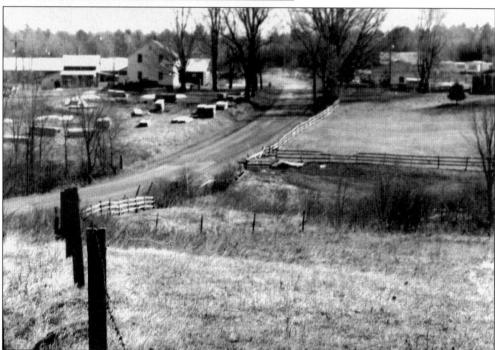

Howard Petteys operated a sawmill on Gurn Spring Road from 1964 until his death in 1987. He and his wife, Madeline Petteys, raised a large family and were well known in Wilton. He served for many years as highway superintendent and as town supervisor.

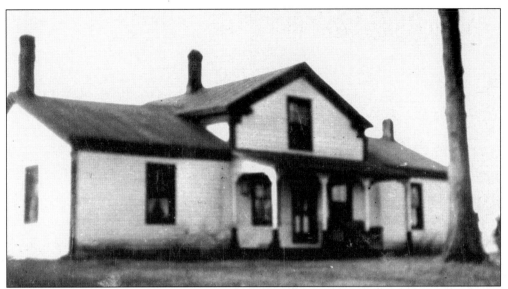

Pictured is the old Kloss farm, on Traver Road. The house has been gone for several years. In 1921, the Kloss family purchased the farm from Frank Buck. It was known as the Kloss place until recent years, when a new home was built on the site. The original barn still stands.

Dating back to very early times (Kayderosseras Patent), this house on Traver Road was known as the Williams place for two generations and as the Pratt place for two generations. This 1920 photograph shows Sherman Stafford Carr seated on the porch. Carr's wife, Mary Cornelia (Betts Pratt) Carr, is standing near the side porch. The original part of the house (facing the road) is well over 200 years old. The ell part (on the right) was added in the late 18th century.

Evelyn E. Crosbie is shown at age two. She was born on January 5, 1902, in the old Ballard Tavern, at the corner of Route 50 and Taylor Road. Her parents were Will Petteys and May Fellows Petteys. She attended the old Ballard School across the road. She worked as a nurse at the Metropolitan Sanatorium, on Mount McGregor.

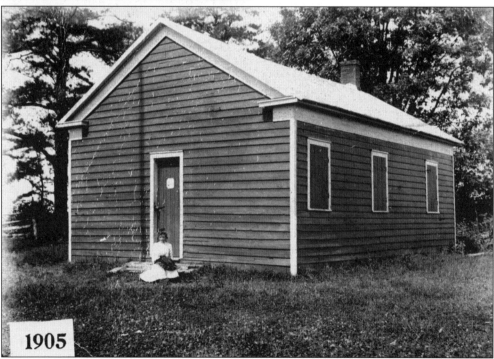

1905

The original Ballard School, seen in this 1905 photograph, was destroyed by fire. Another one-room schoolhouse was built on the same site on Gick Road (Route 50).

The Ballard Tavern, built c. 1800, is located on the corner of Taylor Road and Route 50. It was the main stagecoach stop on the east–west road. During the Revolutionary War, soldiers used the grounds for mustering and drilling exercises in preparation for battle. (Photograph courtesy of the George S. Bolster Collection of the Historical Society of Saratoga Springs.)

The Robbins family originally built the old Pettis homestead on Pettis Road. Mrs. Robbins later married James Pettis, grandfather of William Pettis. The dairy was owned by four generations of the Pettis family and is now deserted. Today, the only existing dairy farm is the Salmonson Farm on Dimmick Road.

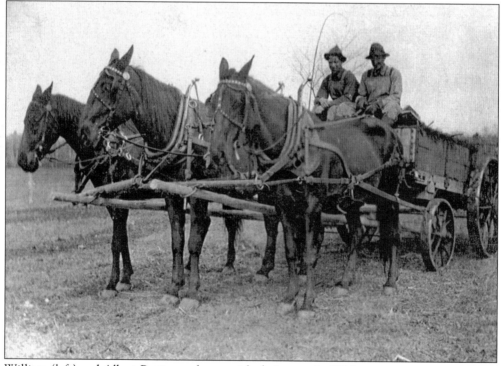

William (left) and Albert Pettis are shown with their team in 1925.

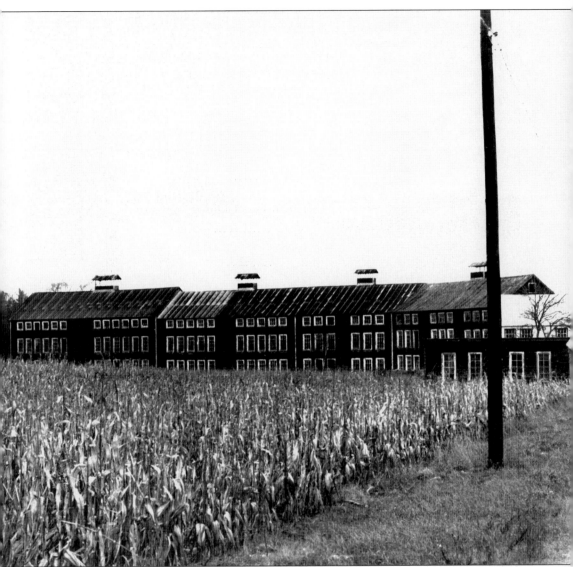

In 1930, Chauncey Record and his wife, Maxine Claiborne Record—who both operated the largest chicken farm in the Northeast until the early 1960s—purchased the Ballard Tavern. Chauncey Record had to cease the farming business due to illness. He died in 1967. Maxine Record came to this country from England and taught school in Tennessee before she came to Wilton. A large framed family tree of the Claibornes hangs in the Wilton Heritage Society Museum. It was acquired from the estate after Maxine Record died. The chicken farm was demolished in 1997.

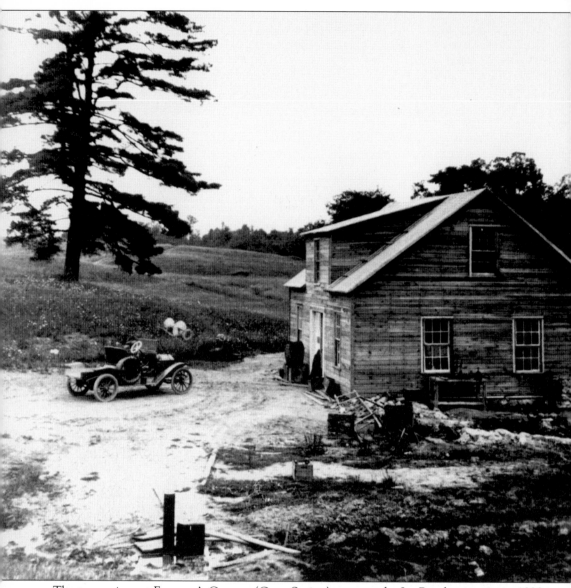

The two springs at Emerson's Corners (Gurn Spring) were on the Ira Roods property in 1898. In 1909, the springs were sold to Leslie A. Cook, who developed them and bottled the mineral water. The bottling plant was in operation in the early part of the 20th century. Many favored the mineral waters from the springs located near the Snook Kill in the north-central part of the town, as they were extremely effervescent. The photograph was taken c. 1914.

# Four
# SOUTHWEST WILTON

This photograph, taken c. 1895, shows the house and family of Warren Perry Stiles, who inherited the property from his father, Peter Stiles, in the mid-1800s. The building was used as a restaurant in the 1930s, when it was owned by Jack Hedrick. It was operated as a seasonal restaurant by the Winetraubs, Liptons, and Zeiberts until 1967, when it was purchased by Bob and Brenda Lee. They served the public on a year-round basis at the Wishing Well, which is still operated by members of the Lee family.

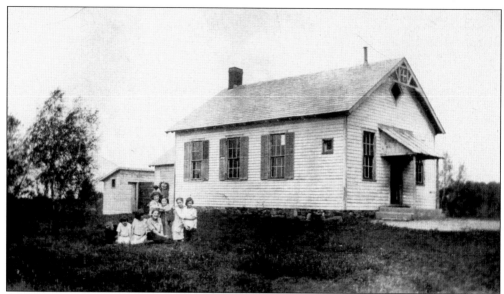

In 1839, John J. Brill donated land for the erection of this school, later known as the Wilton District No. 1 School. In 1928, the building was expanded to a two-room school. The last class was held here in June 1957.

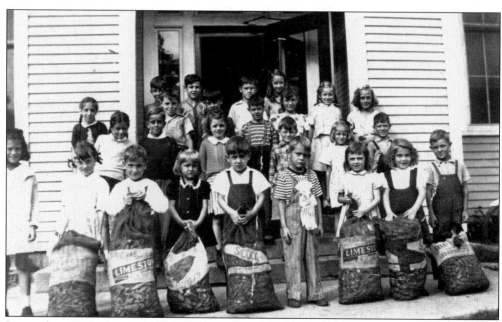

Pictured c. 1944, these schoolchildren at the old Wilton District No. 1 School, on Waller Road, have collected milkweed pods, which can be seen in the mesh bags. The pods were used in the war effort to fill life preservers.

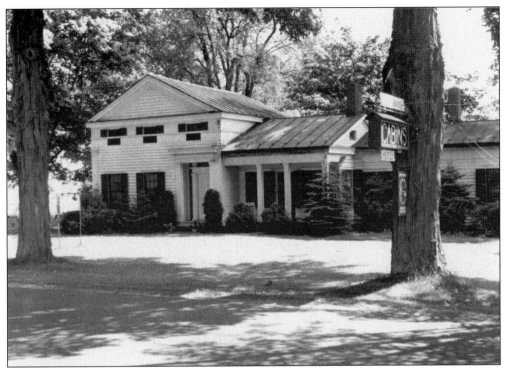

The 1866 Beers map shows this as the W.I. Cooper home, on the corner of Waller Road and Route 9. It has changed hands several times since 1866. In 1947, Charles V. Gesing, who built resort cabins for tourists, purchased the farm. Today, the property is owned by a developer.

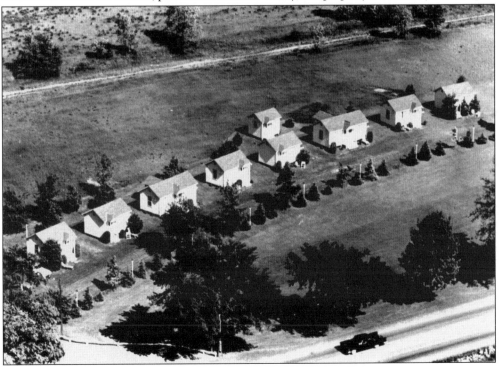

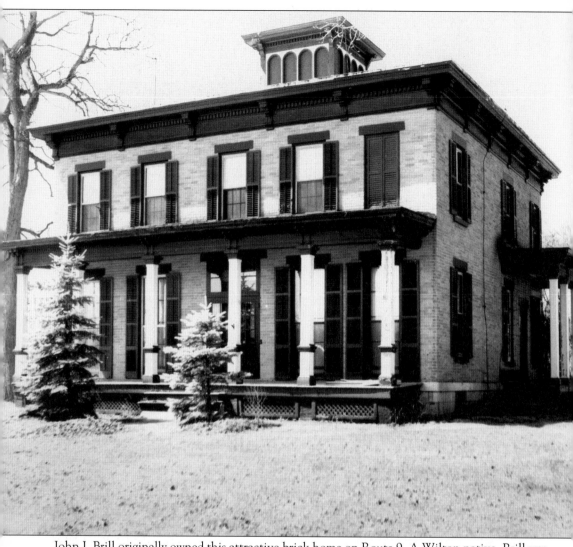

John J. Brill originally owned this attractive brick home on Route 9. A Wilton native, Brill was a prominent gentleman in the early days of the town. He was born in 1827 and was the youngest son of John and Harriet Pearsall Brill. For many years, the property has been known as Pepper's Turkey Farm.

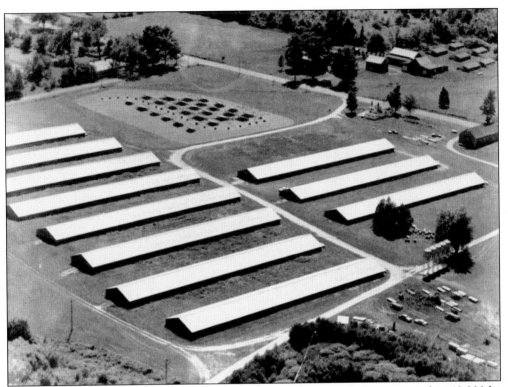

Pepper's Turkey Farm started in 1941 with 1,000 turkeys. The number increased to 40,000 by 1967, the year that Donald Pepper died. The family continued to operate the farm until 1972. People came from all over to purchase turkeys.

One of the many old family cemeteries in Wilton, this is the Brill Cemetery, located east of Route 9 behind the present Association of Retarded Citizens (ARC) building. John J. Brill owned hundreds of acres on both sides of the road in the 19th century. The cemetery is in a very deteriorated condition but can easily be seen near the grove of cedar trees in the field.

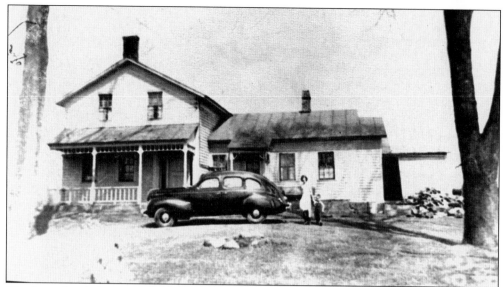

The Jones family has owned this residence on Jones Road for more than 95 years. William S. and Mary Ann Pepper Jones lived here from 1906 to 1918. In 1955, Edward "Bert" Jones Sr. sold a large tract of the 100-acre farm on the south side of the road for the building of the Dorothy Nolan Elementary School.

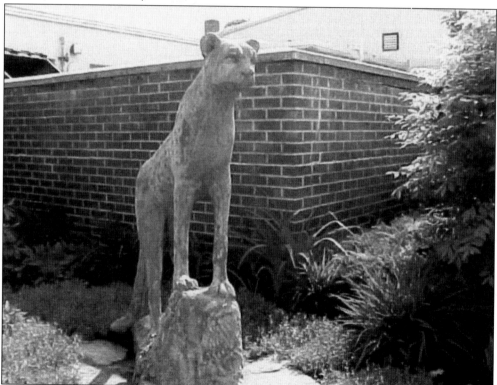

The cheetah is the mascot of the Dorothy Nolan Elementary School, which opened in 1957. The new school replaced a small two-room school on Waller Road. The Grange hall also had one classroom, used for the surplus of students.

"Dorothy Nolan was born Feb. 6, 1887 on the Nolan Farm on Louden Road. She never married and considered the pupils who she taught as her children. She taught for more than fifty years. She was a kind and gentle person. At the dedication ceremony for the new school, she was completely surprised that the school was being named after her." —Lorraine Westcott, town historian, from a history of Dorothy Nolan School by Brian O'Conor, 1991.

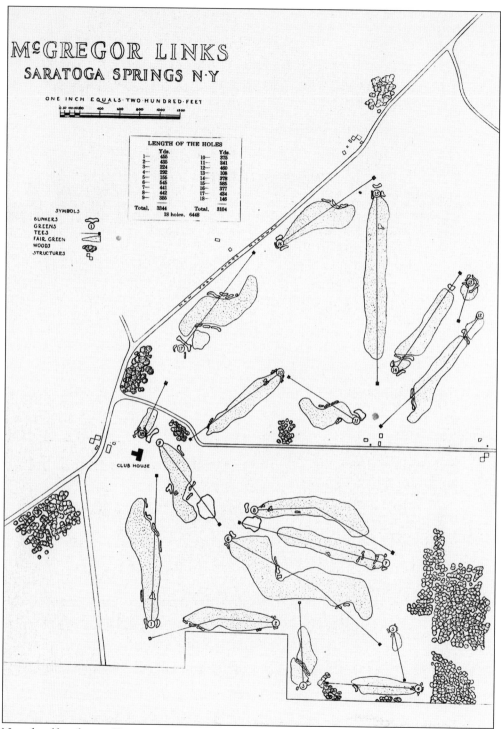

# McGREGOR LINKS
## SARATOGA SPRINGS N·Y

ONE INCH EQUALS·TWO·HUNDRED·FEET

| LENGTH OF THE HOLES | | | |
|---|---|---|---|
| | Yds. | | Yds. |
| 1— | 455 | 10— | 375 |
| 2— | 435 | 11— | 241 |
| 3— | 224 | 12— | 460 |
| 4— | 292 | 13— | 108 |
| 5— | 155 | 14— | 378 |
| 6— | 545 | 15— | 585 |
| 7— | 441 | 16— | 377 |
| 8— | 442 | 17— | 434 |
| 9— | 355 | 18— | 146 |
| Total. | 3344 | Total. | 3104 |
| | | 18 holes. 6448 | |

SYMBOLS
BUNKERS
GREENS
TEES
FAIR GREEN
WOODS
STRUCTURES

CLUB HOUSE

Noted golf architect Devereux Emmet, who assured club members that the course would be playable on June 1, 1921, designed the McGregor Golf Links.

This *c.* 1790 brick Greek Revival house sits proudly on the corner of Smith Bridge and Jones Roads, surrounded by the land farmed for generations. Inside the house is a beehive oven, connected to the center chimney. A trap door in the ceiling once led to a sleeping loft. The windows have hand-rolled glass. The Vincek family has owned this home since 1920.

Warren B. Collamer built this mansard-style home on Smith Bridge Road in the mid-1800s. It was enlarged in 1870 and was later acquired by Collamer's daughter Mary Ella Collamer Smith and his son-in-law Edgar J. Smith. The movie *Ghost Story* was filmed here in 1986.

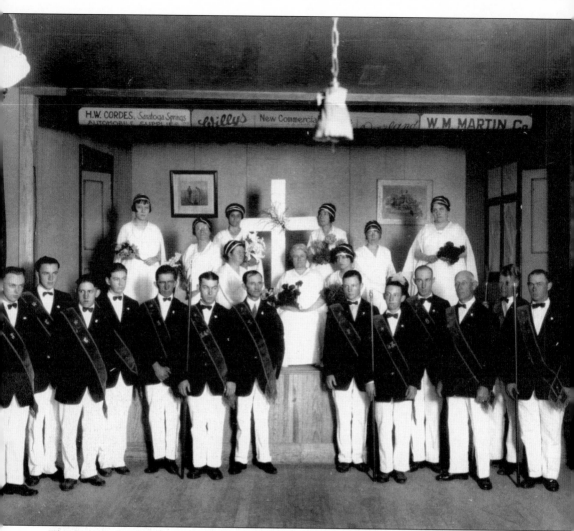

The Grange has been active since it was formed in 1907. The Grange members were present for the annual degree ceremony in 1925. From left to right are the following: (front row) Hildreth Hodgson, Fred Hettling, Albert Carr, John Freebern, Earl Carr, Ralph Perry, Harry Green, Roy Stiles, Frank Parks, Irving Perry, J.L. Gregory, Harry Berry, Frank Perry, and Germain Whelden; (back row) Eulah Gregory, Kit Potter, Clara Crawford, Bessie Stiles, Lottie Carpenter, Alice Batchelor, Carrie Berry, Helen Lockwood, and Alma Gregory. (Photograph courtesy of the George S. Bolster Collection of the Historical Society of Saratoga Springs.)

# *Five*

# SOUTH WILTON

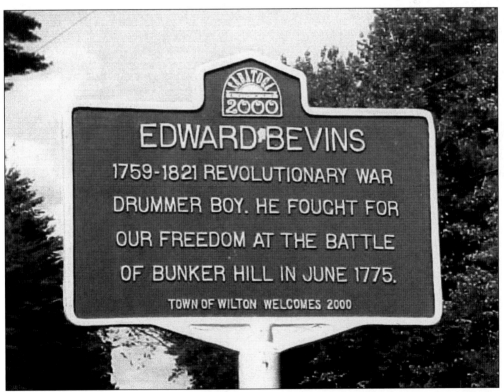

Edward Bevins was a drummer boy in the Revolutionary War. At the Battle of Bunker Hill, the drummer boys were pressed into service. In his later years, Bevins told tales of the battle to children. He is buried in the Louden Cemetery.

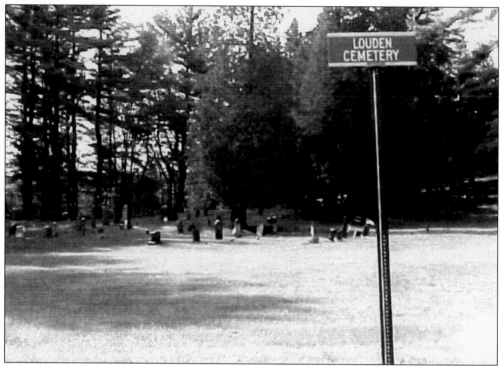

The Louden Cemetery contains the graves of many Civil War veterans, mostly from the 77th Regiment New York State Volunteers of 1861–1865. Edward Bevins's daughter Polly married Jason Adams and lived in the Louden Road area. Jason Adams donated the land for the cemetery and the church.

The Methodist church on Louden Road was built in 1833. It burned to the ground on June 6, 1931. Former residents still remember the shed in the back where they rested their horses in the shade.

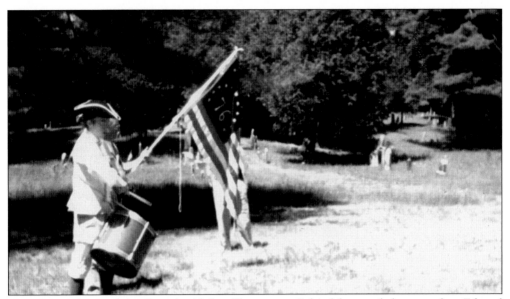

In 1999, students of the Dorothy Nolan Elementary School honored drummer boy Edward Bevins with a historic marker. Nicholas Kopp, a student from Corinth Central School, played the part of the drummer boy, and the Dorothy Nolan Bell Choir played songs appropriate for the Revolutionary War. The drummer led a march to the grave of Edward Bevins, and the students thought that the grave should be marked with a new stone. This was accomplished with the cooperation of the Saratoga County Veterans Bureau.

Three baseball players—from left to right, Frank Westcott, James Archer, and John West Jr.— stand outside the Wilton District No. 8 School, "the Little Red Schoolhouse." Located on Route 50 north of Edie Road, the building has been remodeled and is now a private residence.

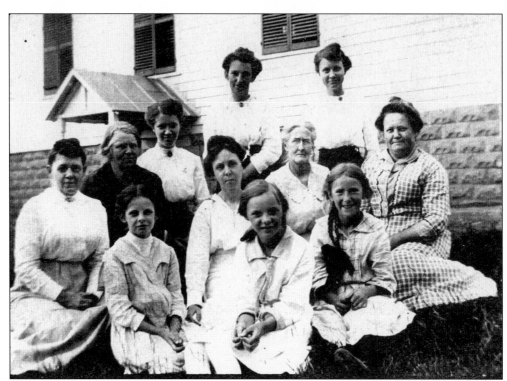

The South Wilton Ladies Aide Society raised money for the church and gave charitable gifts to the needy in the community.

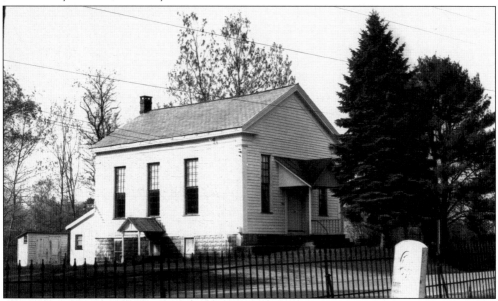

The South Wilton Methodist Church was built on Route 50 in 1854 and served the community for more than 100 years. The congregation combined with Wilton and Gurn Spring churches to form the Trinity Methodist Church, on Ballard Road. Although the building no longer serves as a church, many older citizens have good memories of activities such as Christmas parties and programs.

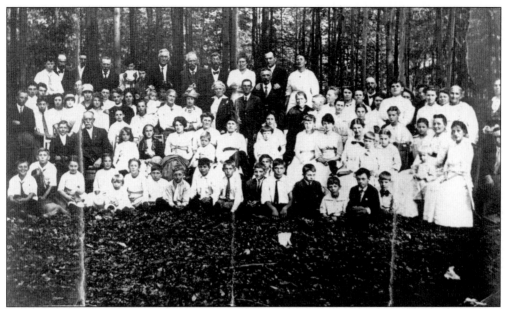

The congregation of the South Wilton Methodist Church was very active in community affairs. The group helped maintain the cemetery that was across the road (Gick Road). Many church suppers and Christmas programs were enjoyed.

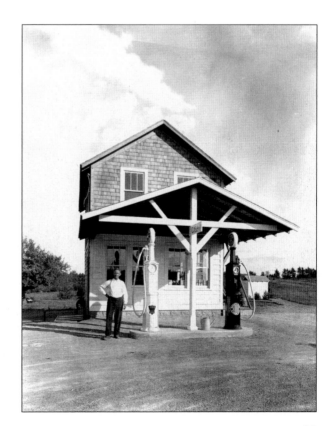

Charles Van Wagner operated a gas station on Route 50 c. 1930. The gas station was later run by Mrs. "Minnie" Steuer. Today, the building is a Christmas gift shop owned by Steuer's grandson Michael Messinger.

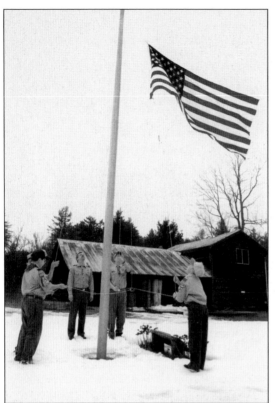

Scouts from Wilton Troop 24 lowered the flag for the last time at Camp Saratoga in Wilton on April 12, 2001. The camp had hosted Saratoga County Scouts since 1929. From left to right are Cub Scouts Allen and Jamie Lounsbury, Den 4 leader Bob Lounsbury, and Boy Scouts Jim and Chris Reepmeyer.

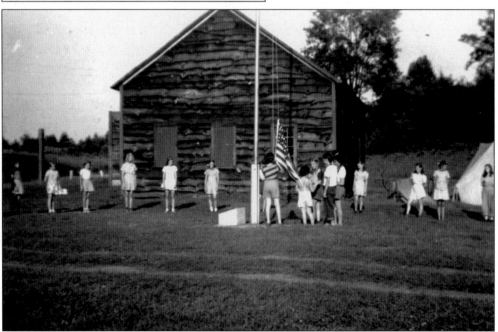

Locals all knew of the Boy Scout camp on Scout Road. In 1929, the Scout organization purchased 320 acres from the Gick family. This 1947 photograph shows Girl Scouts at the camp. No longer used solely by the Scouts, the camp is now owned by the town.

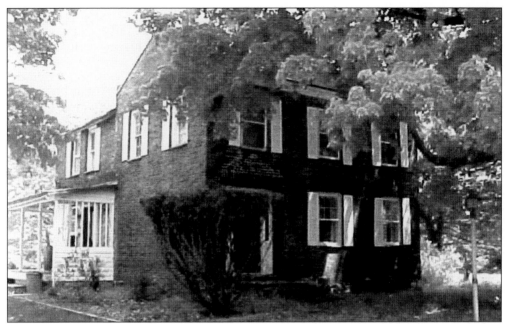

The brick home of Hugh Groesbeck and his wife, Elizabeth, stands surrounded by ancient trees on Louden Road. The property of 100 acres was given as compensation to a Revolutionary War soldier after he was discharged. Hugh Groesbeck died in 1840, and his wife died in 1843. They are buried in the Jaycox Cemetery. Hugh Groesbeck was a trustee to the Loudon Church.

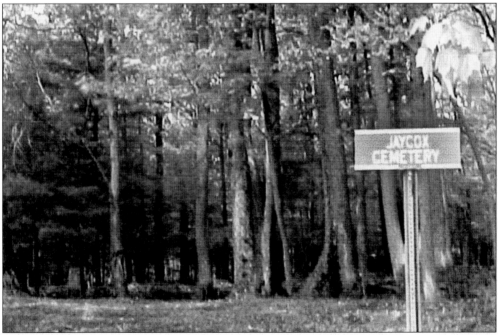

This small cemetery is located on a farm on Louden Road. Betsy Jaycox, wife of Benjamin Jaycox, died on June 6, 1828, at the age of 43. The Jaycox family lived south of Kendrick Hill (now in Wilton) before the Revolutionary War. The family had two sons who marched with the British army. When the British surrendered, the sons left for Canada and never returned.

Wilton was a farming community in the early days. This old barn, owned by Bartlett Grippen, once stood on Old Gick Road. The house still stands but has been converted to apartments.

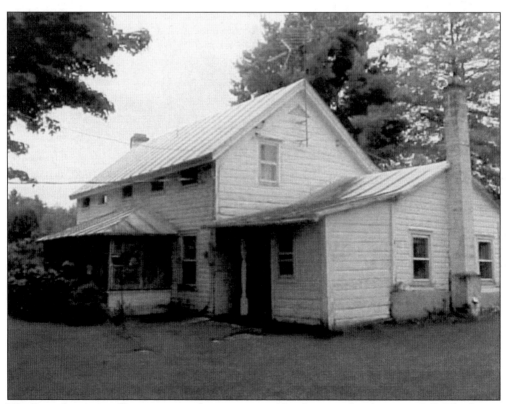

The Boice house is still a private residence, occupied by the same family since 1960. The house dates from before 1812, and the property was given in payment for service to a veteran of the Revolutionary War, perhaps Boice. The original owner is buried in the Boice Baker Cemetery.

86

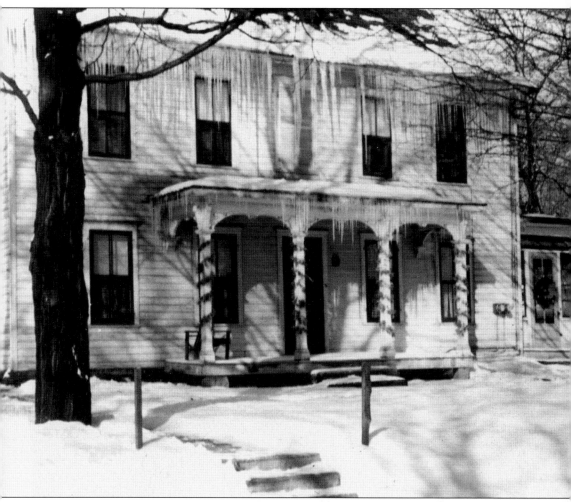

Bartlett B. Grippen owned a large dairy farm on Old Gick Road from 1868 to 1900. William B. Perry owned the property from 1900 to 1948. Frank Perry farmed the land for many years after 1948 until his death.

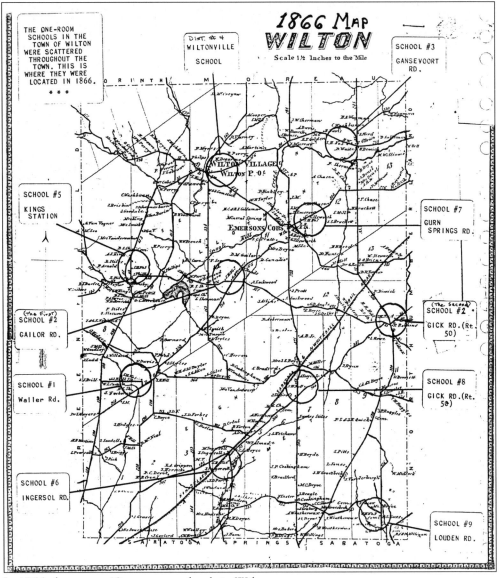

In 1866, there were 10 one-room schools in Wilton.

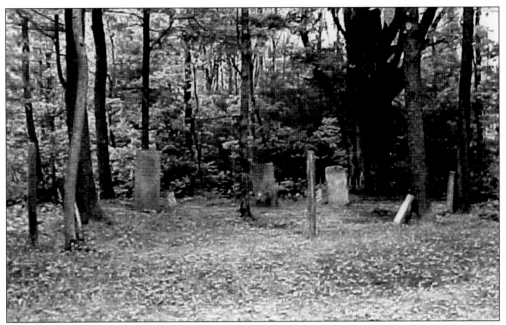

The Ruggles Cemetery is on Ruggles Road in the southeast part of Wilton in a grove of old trees. Of the many stones in the cemetery, only three can be read. They are those of Beriah Ruggles, who died on December 10, 1852, at age 70; Ann Ruggles, who died on September 30, 1861, at age 25; and Francis Ruggles, who died on April 8, 1860, at age 51.

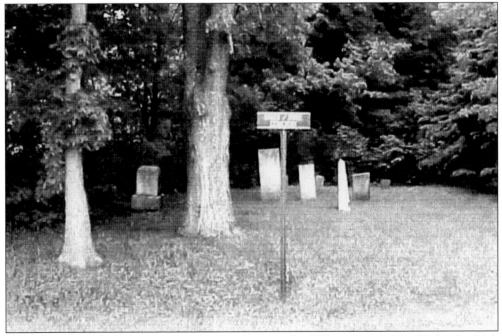

The Baker Boice Cemetery is on Louden Road next to the Wilton District No. 9 School, which has been converted to a private dwelling. Charles Baker and his wife, Jane, are buried there. Their stones state that Baker was born in 1825 and his wife in 1835. The Bakers were prominent citizens in early South Wilton. John Boice was the original owner of a nearby house.

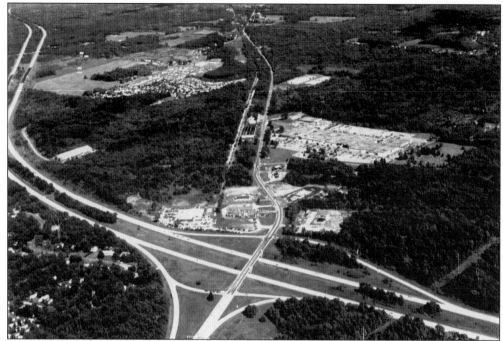

The area around Northway Exit 15 has developed rapidly since 1972, when the Pyramid Mall was built. When this aerial photograph was taken, there was still some green area left.

Since Wilton was a rapidly growing community, the need for an emergency squad and building arose. The squad was registered with the state on April 26, 1982. Groundbreaking ceremonies for the building were held on April 28, 1983. The Wilton Emergency Squad continues to serve the community.

*Six*

# MOUNT MCGREGOR

After Duncan McGregor purchased the mountain in 1870 for back taxes, groups of people would gather for Sunday picnics. At the Eastern Overlook, a gazebo was built. On an August day in 1899, the Curtis family enjoyed the quiet retreat.

# Mt. McGregor.

This Mountain, situated about ten miles north of Saratoga, has gradually become a favorite resort for strangers visiting the great watering place, and the Mount McGregor Railroad, which connects the two, is one of the most remarkable achievements of civil engineering of the present time, running as it does to the top of Mount McGregor, *eleven hundred feet* above Saratoga Springs, and with a grade in some places as high as *two hundred and forty-six feet* to the mile. The trip up and back makes one of the pleasantest out of Saratoga.

From the summit of the Mountain is obtained a magnificent view of the Hudson River valley; with the Green Mountains to the east, the Adirondacks to the north and the Catskills to the south.

The Drexel Cottage, in which General Grant died, is open to the public, and makes the visit to Mount McGregor of historic interest to all.

## TIME TABLE.

## Mt. McGregor R. R. Co.

### TAKES EFFECT JULY 20, 1892.

| Leave Saratoga. | Arrive Mt. McGregor. |
|---|---|
| 9.00 A. M. | 9.35 A. M. |
| 11.00 " | 11.35 " |
| 12.30 P. M. | 1.05 P. M. |
| 3.20 " | 3.55 " |
| 5.00 " | 5.85 " |
| 6.40 " | 7.15 " |
| 9.40 " | 10.15 " |

| Leave Mt. McGregor. | Arrive Saratoga |
|---|---|
| 7.00 A. M. | 7.35 A. M. |
| 10.00 " | 10.35 " |
| 1.15 P. M. | 1.50 P. M. |
| 2.30 " | 3.05 " |
| 5.00 " | 5.35 " |
| 6.00 " | 6.35 " |
| 7.45 " | 8.20 " |

### SUNDAY TRAINS.

| Le Saratoga. | Ar Mt. McGregor | Le Mt. McGregor. | Ar Saratoga |
|---|---|---|---|
| 11.00 A. M. | 11.35 A. M. | 9.30 A. M. | 10.05 A. M. |
| 12.30 P. M. | 1.05 P. M. | 1.15 P. M. | 1.50 P. M. |
| 3.30 " | 4.05 " | 2.30 " | 3.05 " |
| 6.30 " | 7.05 " | 5.45 " | 6.20 " |

By 1883, the mountain could be reached by riding the Saratoga, Mount McGregor and Lake George Railroad. The 10-mile narrow-gauge railroad traveled over many trestles spanning gorges on the mountain. It took the builders only three months in 1882 to complete this engineering feat.

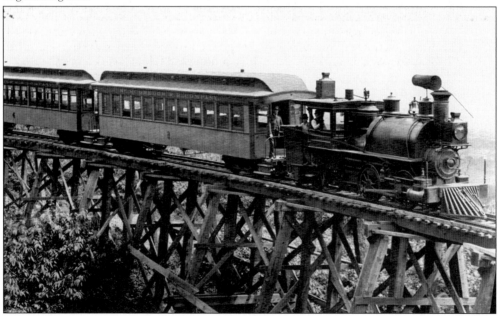

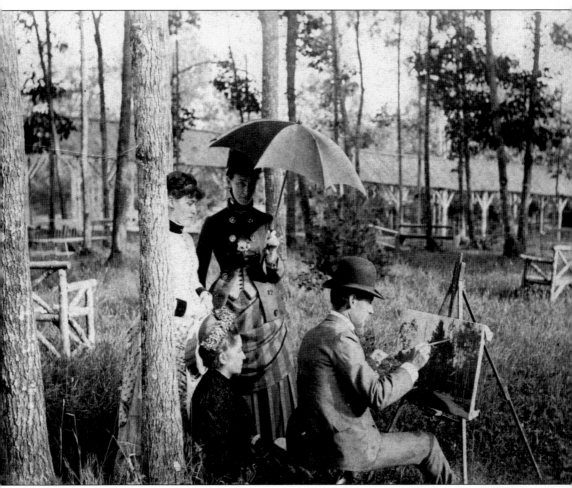

A long, covered wooden portico joined the railroad station and the Balmoral Hotel. Small cabins and an art gallery dotted the mountain. People wandered the many walkways, which led to Artist Lake, Lake Ann, and Lake Bonita, where boating and fishing were enjoyed.

As soon as the railroad was completed, construction on the Balmoral Hotel began. The hotel was one of three in the United States to be lit by electricity. It could accommodate 250 guests. Each room opened onto the wide veranda encircling the structure. On December 1, 1897, the hotel was destroyed by fire. Shortly thereafter, the railroad was dismantled.

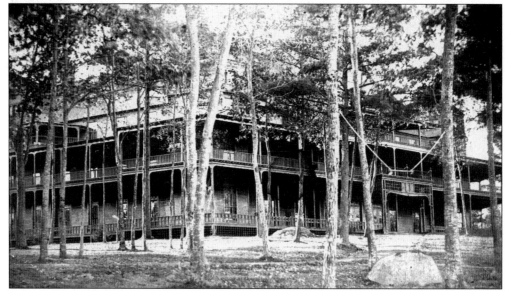

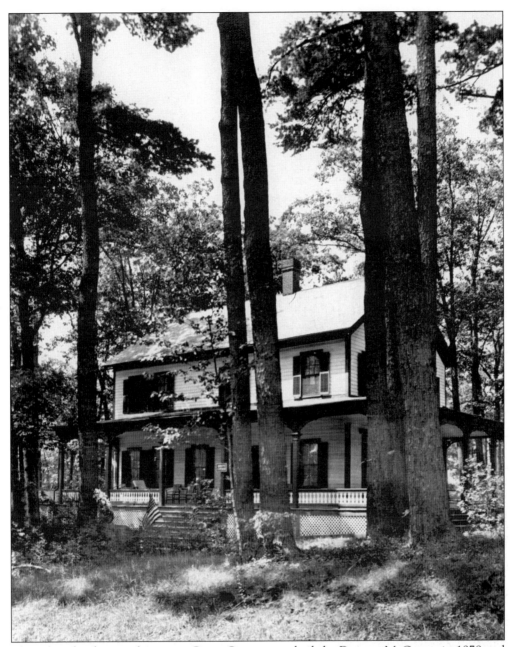

The cabin that became known as Grant Cottage was built by Duncan McGregor in 1878 and was known as Mountain House. Joseph Drexel, one of the developers of the Balmoral Hotel, knew that Gen. Ulysses S. Grant was suffering from terminal throat cancer and offered the general the cottage for the summer of 1885. Grant came to the cottage in June 1885 and, during his stay, completed his memoirs, which would sustain his family after his death. Grant died at the cottage on July 27, 1885.

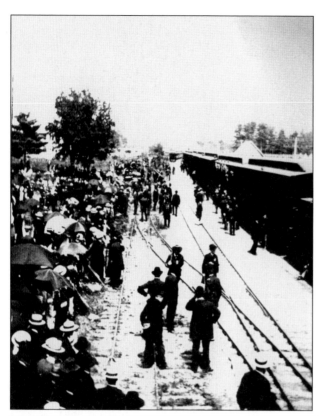

The funeral of Ulysses S. Grant took place at the cottage on August 4, 1885. More than 1,000 people crowded the mountain. After the funeral, Grant's body was brought to Saratoga and Albany. It was then taken to New York City for burial.

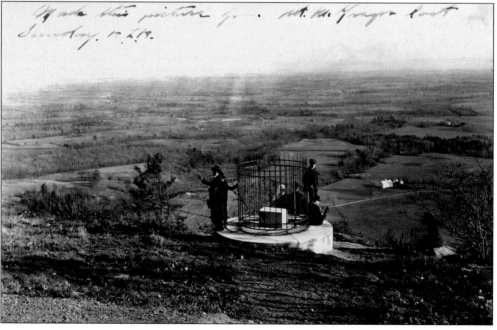

A monument dedicated to Ulysses S. Grant was erected at the Eastern Overlook, as was a large 50-foot flagpole. Suye Narita Gambino often raised the flag there during her years as caretaker of Grant Cottage.

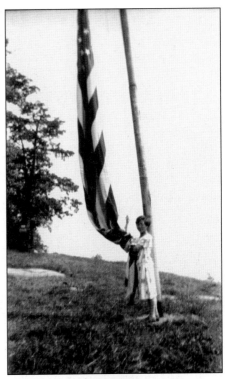

In the late 1980s, the New York Sate Department of Parks, Recreation and Historic Sites (which owned the cottage) wanted to close the site. The Friends of U.S. Grant Cottage was formed to work with the state to keep the museum open to the public. Members often reenact the family and life at the cottage.

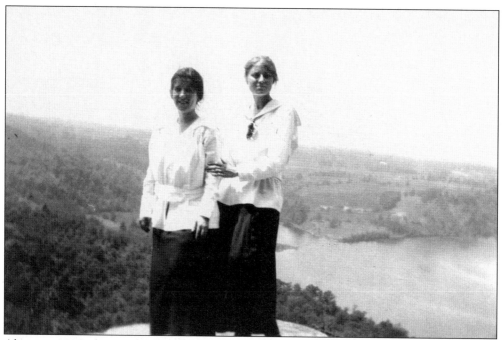

Above, a 1917 photograph shows two young women at the Western Outlook. Below is an artist's impression of the view down on the Hudson River *c.* 1883. In the days of the hotel and the sanatorium, there was a well-worn path to the Overlook. It is no longer accessible to the public because the state department of corrections has taken over the buildings that were used by the Wilton Developmental Center.

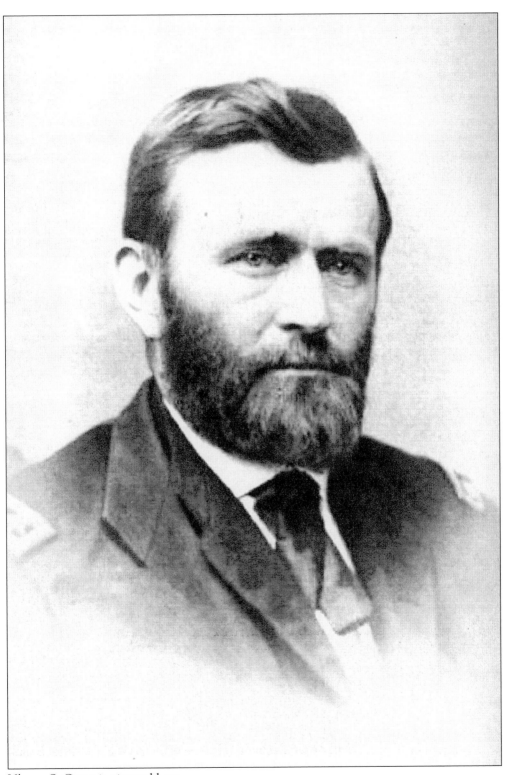

Ulysses S. Grant is pictured here.

This is an artist's interpretation of Lake Bonita, the largest of three lakes on Mount McGregor.

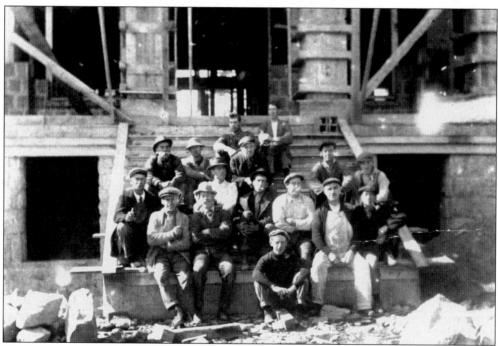

Workmen pose on Mount McGregor during the construction of the Metropolitan Sanatorium. The man in the center is Robert Hoey (with hat and cigarette), grandfather of Nancy Bidwell of Gansevoort. The sanatorium was built in 1911–1912.

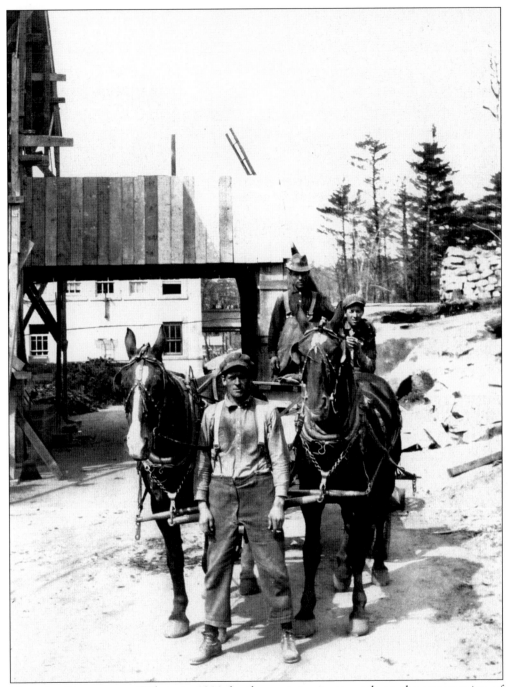

Many families came to Wilton in 1911 for the opportunity to work on the construction of Metropolitan building on Mount McGregor. They stayed because they had a pleasant community and a dependable workplace.

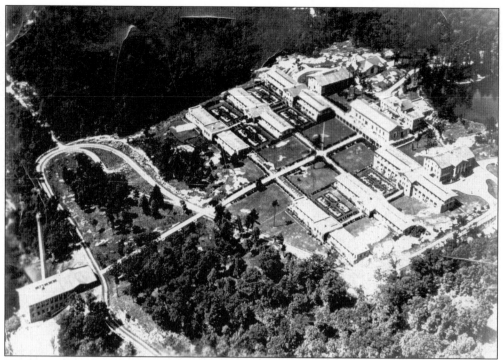

The Metropolitan Life Insurance Company sanatorium complex is pictured in an aerial photograph. In 1945, the complex was sold to the state for use as a rest camp for veterans.

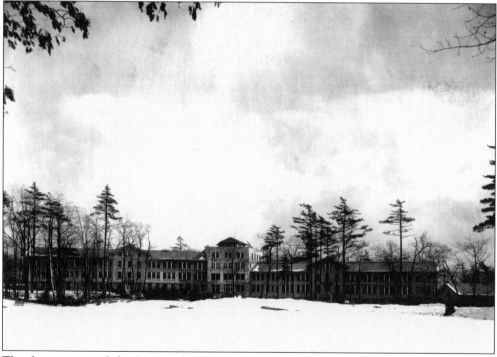

The first patient of the Metropolitan facility was admitted on July 25, 1913. The formal dedication was on June 20, 1914. The property is now a state correctional facility.

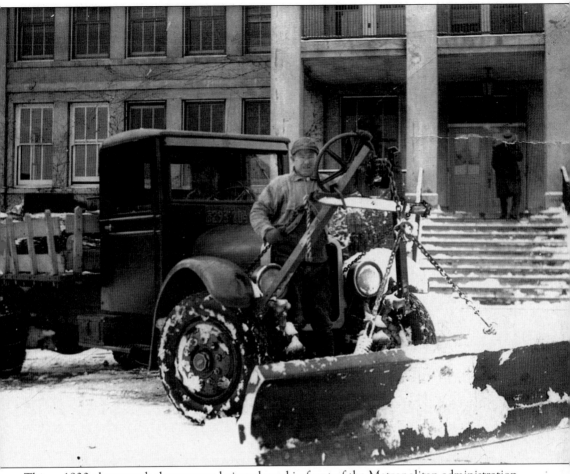

This *c.* 1930 photograph shows snow being plowed in front of the Metropolitan administration building on Mount McGregor. The man in front of the truck is Ken Petteys.

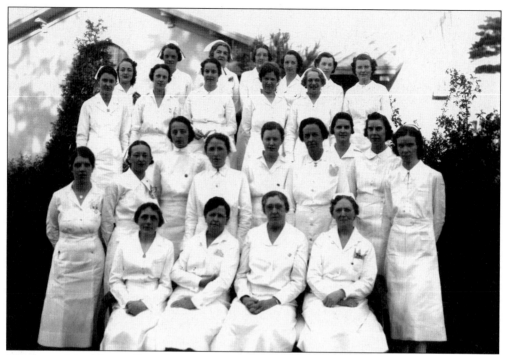

Members of the Metropolitan Sanatorium nursing staff are shown in 1938.

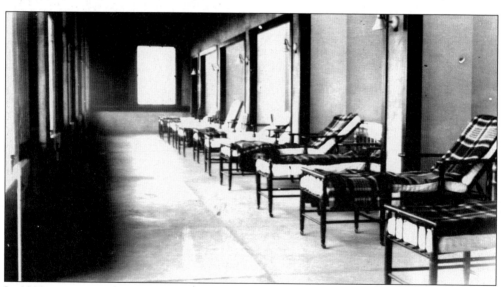

In 1919, patients at the Metropolitan Sanatorium slept on open-air porches. It was considered medically necessary to fill the lungs with fresh mountain air to cure tuberculosis. The need for these cures ceased in the 1940s with the development of improved medicines.

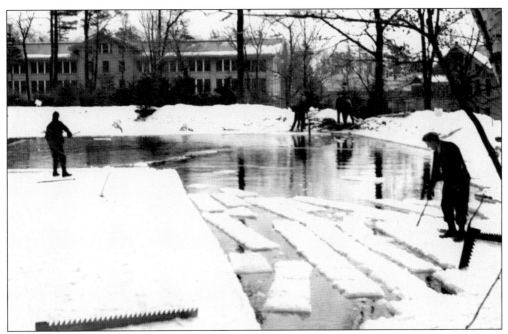

It was a practice to cut ice on Artist Lake on Mount McGregor for several years while the Metropolitan Life Insurance Company operated the sanatorium. The photograph was probably taken during the 1930s.

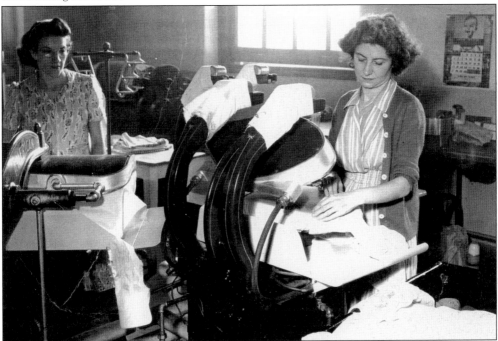

Frances Vandecar (left) and Catherine McDermott worked in the laundry on Mount McGregor. The Metropolitan Life Insurance Company, New York State Veterans Department, and the New York State Department of Mental Hygiene employed local citizens. Today, the state department of corrections continues to do the same.

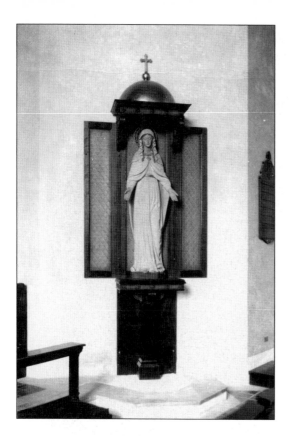

This statue of the Madonna was located in the Chapel of St. Mary, on Mount McGregor.

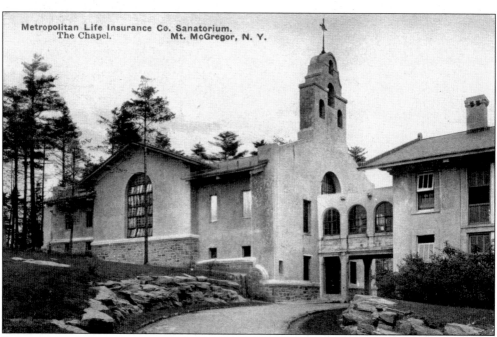

Patients attended nondenominational services in this chapel on Mount McGregor.

Suye Narita (Gambino) is shown with her dog on Mount McGregor. She came to the mountain at age 13 to receive treatment for tuberculosis and stayed for the rest of her life. In 1941, she became caretaker. During World War II, she was quarantined at the cottage because of her Japanese nationality.

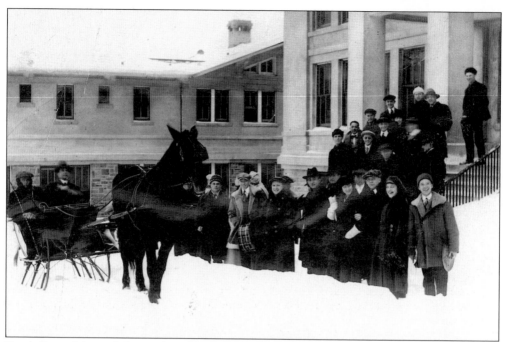

Frank Perry delivered the mail in this sled. His passenger is identified as Joseph Drexler. The sled is now on exhibit in the Wilton Heritage Society Museum.

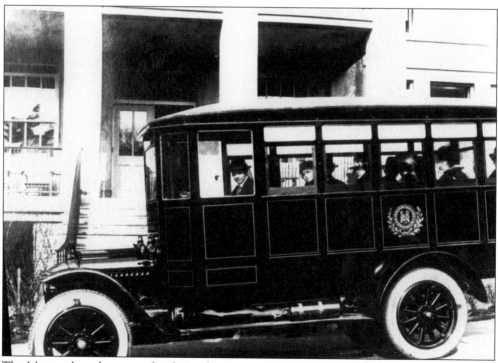

The Metropolitan bus was a familiar sight as it transported visitors, patients, and employees up the mountain in the 1920s and 1930s. The bus traveled to and from Glens Falls and Saratoga.

This snowy scene from the days of the Metropolitan Sanatorium shows one of the homes for staff personnel.

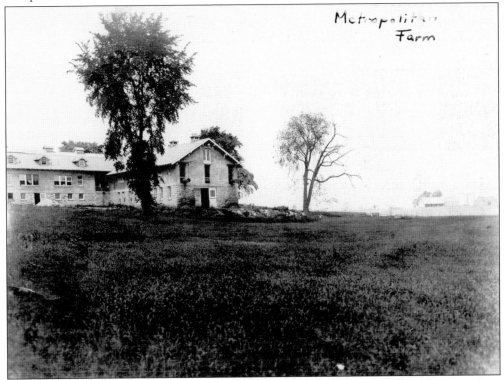

Located on Northern Pines Road (Old Route 9) was Metropolitan Farm No. 1, a dairy farm serving the patients and staff at the sanatorium. On the right is Farm No. 2, which was on the site now occupied by the state trooper barracks on Ballard Road. Farm No. 2 was where the pigs and chickens were raised. The chicken farm was where Ballard Elementary School now stands. In August 1996, the old farm was razed to make way for the building of Ace Hardware.

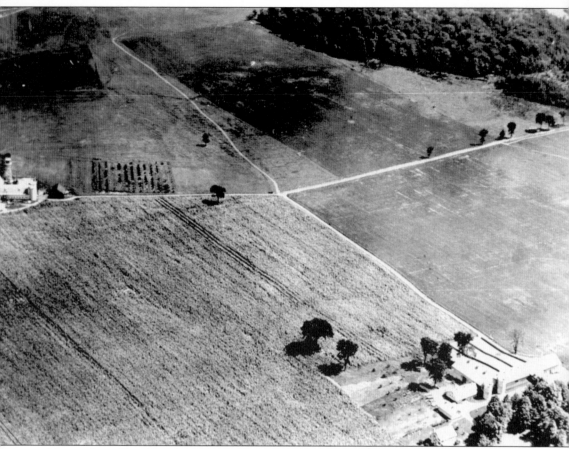

Metropolitan Farm No. 2 was located on the site of the state police station on Ballard Road (center left). Farm No. 1 was located on Northern Pines Road. The dirt roads connecting the farms no longer exist.

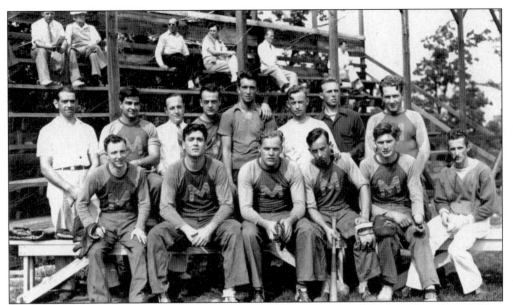

Recreation was important for the recovery of the tubercular patients at the Metropolitan Sanatorium. This baseball team is probably made up of staff and patients.

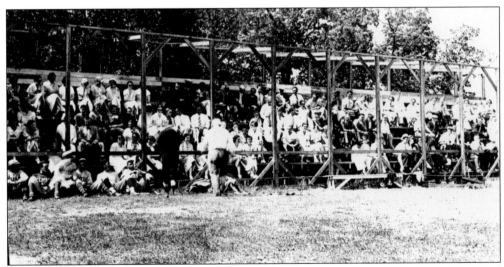

The stands are full at this very popular spectator sport. The former patients have commented in letters that the feeling of "one big family" was an important factor in their recovery.

Tony Salerno was one the Metropolitan employees who went on to work for the Veterans Administration and the New York State Department of Mental Hygiene.

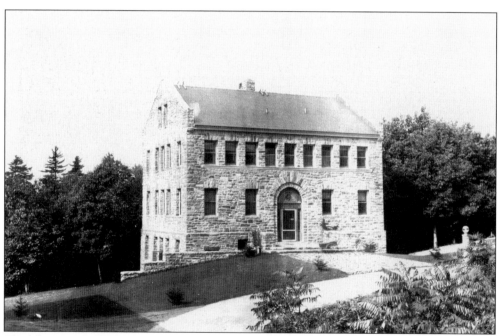

The laboratory building was an essential part of the medical team that worked for the successful cure of the disease of tuberculosis. By the mid-1940s, the sanatorium was no longer necessary. The Metropolitan closed the Mount McGregor site and sold it to the state.

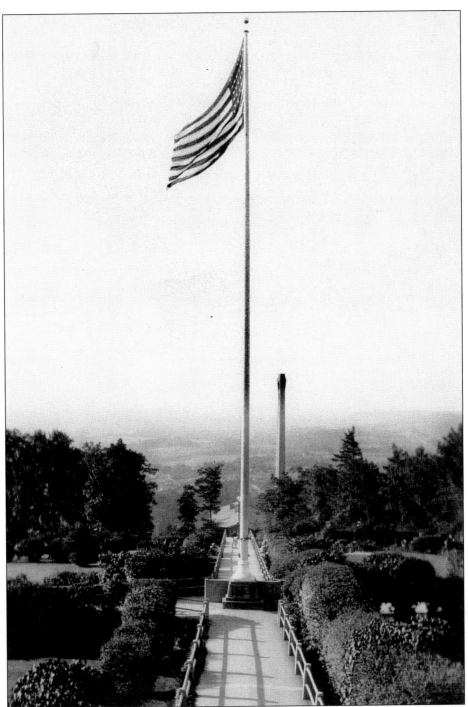

The ramp with the center flagpole served as the approach to the administration building and was a focal point for activities of the Metropolitan and also the New York State Veterans Administration. The ramp covered a tunnel that went from the basement of the administration building to the laundry. It is said that not only laundry but also the deceased were sent down the hill so the hearse was never seen by the patients to maintain their feeling of well-being.

The rehabilitation of the returning veterans was very similar to the recovery of tubercular patients. Fresh air and recreation were important for their physical and mental well-being. The *Mountain News* was good for the morale and contributed to the feeling of family.

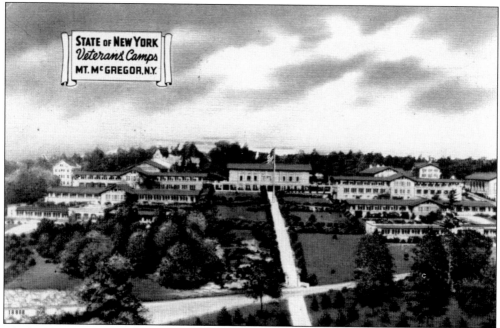

The buildings of the veterans' camp remained the same as they were during the sanatorium years.

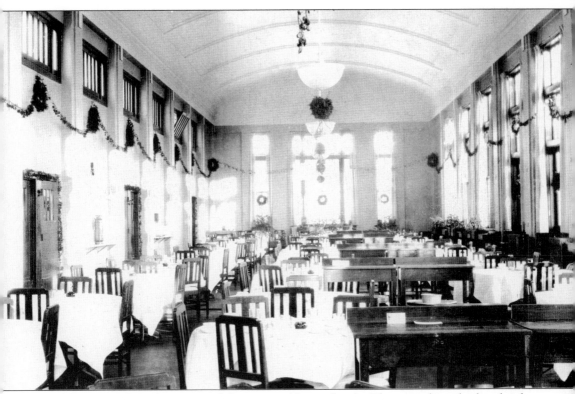

The dining room was the center of the veterans' home family. The nourishing food and rich milk from the farm was the mainstay of the plan to return the veterans to a stable, healthy lifestyle. The farm continued throughout the veterans' days on the mountain.

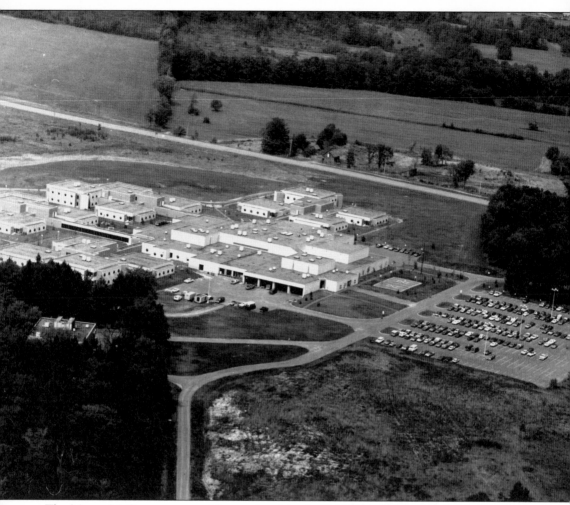

The Mount McGregor veterans' home closed in April 1960, and the state decided to use the complex as a facility to help those with developmental disabilities. A new complex was built on Ballard Road. The Wilton Developmental Center replaced the school on the mountain in 1975. This aerial view shows the modern complex. The most notable feature is the large tinted "bubble" windows.

The new complex was divided into four separate communities joined by a common village square. Each community represented a different county where clients would be placed in a family setting. This was a distinct change from the medical plan to the social plan.

# Wilton Developmental Center

## Dedication

TUESDAY, JUNE 8, 1976

2:00 P.M.

**PROGRAM**

2:00 P. M. - Main Entrance

National Anthem _____ Argyle Central School Concert Band
*Bob LaFera, Director*

Invocation _____ Reverend Thomas Parke, Chaplain
*Wilton Developmental Center*

Welcome _____ Emanuel Rechter, M.D., Director
*Wilton Developmental Center*

Remarks _____ Gertrude VanDusen, President
*Board of Visitors*
*Wilton Developmental Center*

Remarks _____ Thomas A. Coughlin, III
*Deputy Commissioner for Mental Retardation*
*Department of Mental Hygiene*

Remarks _____ William D. Voorhees, Jr., M. D., Director
*Northeast Regional Office*
*Department of Mental Hygiene*

Remarks _____ Lawrence C. Kolb, M.D., Commissioner
*Department of Mental Hygiene*

Remarks and Dedication_ Charles Schlaifer, Chairman
*Facilities Development Corporation*

Remarks _____ Eleanor Pattison
*(representing Edward W. Pattison,*
*U. S. Representative)*

Benediction _____ Reverend Daniel O'Leary, C. SS. R., Chaplain
*Wilton Developmental Center*

3:30 P. M.

    Developmental Services Fair
    **tours of facility**
    **refreshments**

Clients were to be received from larger institutions throughout the state. After a short period of training, they would be placed in the community. The plan was that the larger facilities would then be closed. The Wilton Developmental Center was a major employer for the area.

117

The state corrections department opened the Mount McGregor facility in 1976 after the clients of the New York State Department of Mental Hygiene were transferred to the Wilton Developmental Center. Vehicle traffic was then restricted on the Mount McGregor road to corrections employees and to Grant Cottage visitors and volunteers. The guard house is at the base of the Mountain Road. All traffic must stop here.

The sign at the bottom of the Mount McGregor road guides the public to the complex.

The administration building has remained basically unchanged by corrections and is used in the same capacity as it was during the days of the sanatorium and the veterans' home.

The Wilton Heritage Society was formed in 1967. The members soon realized that the town's sesquicentennial year was quickly approaching, and they prepared feverishly for the coming celebration. The community cooperated in every way, and the parade was the main event.

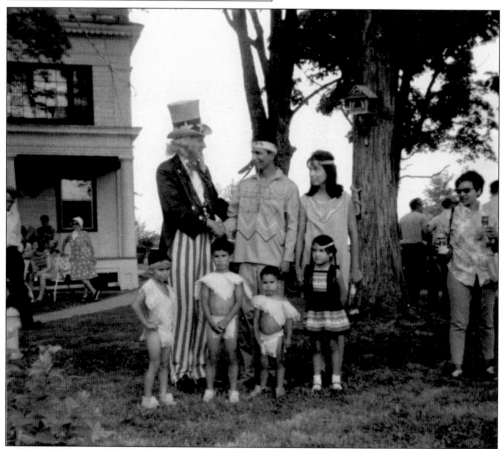

John W. Rusk depicted Uncle Sam. He was , the father of Harry Rusk, whose family lived in the house that was once the Wilton Academy. The Native American family consists of local children.

## Seven

# SPECIAL EVENTS

Jerome Orton holds the time capsule containing a remembrance of the Wilton community in 1968. Enclosed were important documents of the Wilton Heritage Society, bus schedules, newspapers, and so on. The most important document was a list signed by people attending the celebration. This sheet of paper, measuring some 12 feet in length, is a permanent record of the citizens in 1968. The capsule was buried in the space between the doors of the Wilton Heritage Society.

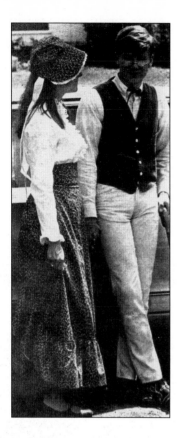

Ready for the sesquicentennial parade are 16-year-old Jan Van Rensselaer of Wilton and 18-year-old Ainslie Wagner of Saratoga Springs. They are dressed in their finest 1890s-style clothes.

The Wilton Fire Department Ladies Auxiliary, in costume and drawn by a lawn tractor, was well represented in the parade. Several fire departments, a drum and bugle corps, and a band also took part in the parade.

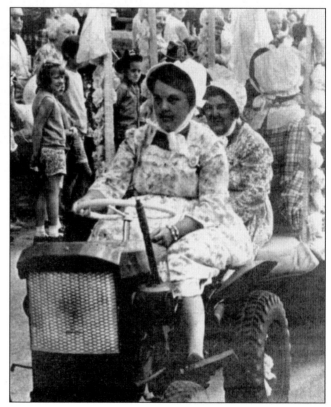

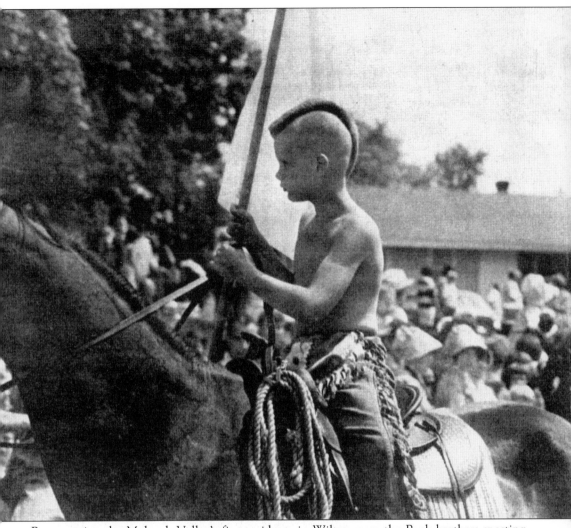

Representing the Mohawk Valley's first residents in Wilton were the Rusk brothers sporting Mohawk haircuts and Native American dress for the occasion. A crowd of more than 1,000 was on hand for the parade.

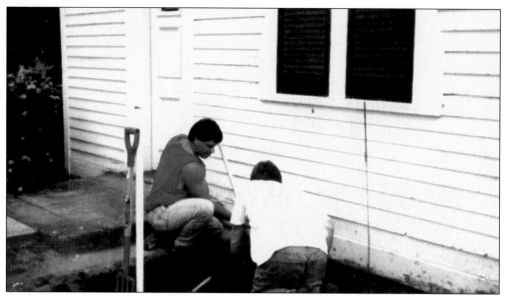

In 1999, the Wilton Heritage Society agreed that it would be appropriate to search for the time capsule and open it to celebrate the new millennium. Scott Harrington (left) and Paul Doescher finally unearthed the capsule after much probing. The capsule was buried close to the foundation at a great depth. The contents were wet, but they were salvaged.

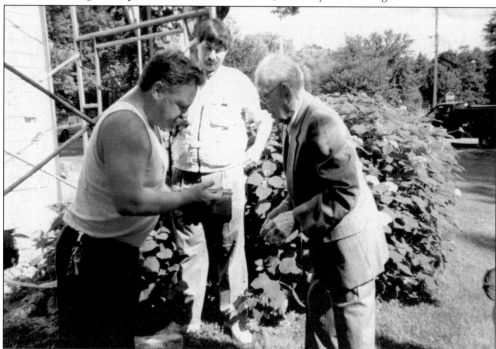

A time capsule in the form of a small copper box was buried under the Wiltonville Church when the building was constructed in 1871. It contained the names of the founders and other important documents, according to written record. Many community volunteers made an intense search in early 2000. The contents were disappointing because water had seeped into the box. From left to right are Marty Burdick, Brendon O'Donnell, and Ken Petteys (age 96).

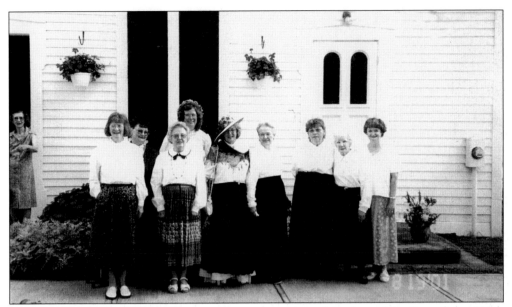

The members of the Wilton Heritage Society participated in the celebration of the 130th anniversary of the Wiltonville Church. In the foreground, from left to right, are Kathleen Doescher, Carole Parkhurst, Margaret Porter, Rachael Clothier, Doris Wilder, Jean Woutersz, Betty Harrington, Jean Gainer, and Catherine Orton. Grace Hawthorne is in the left background.

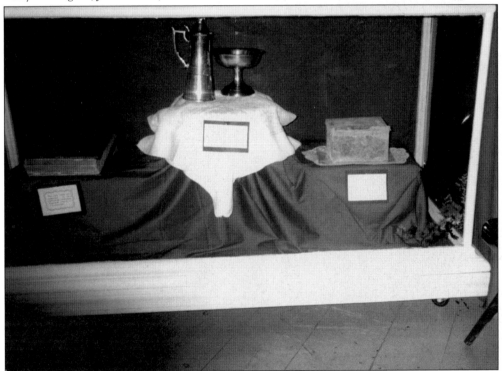

The original communion set of the Wiltonville Church is on display at the Wilton Heritage Society Museum. Baptism dresses and the Bible given to the church by Dr. Marshall are also on display. Dr. Marshall donated the land for the church.

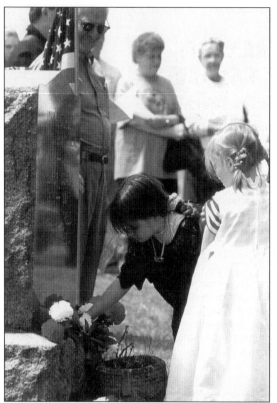

A Memorial Day service was held at the John Ellsworth Cemetery in Gurn Spring in 2001. Civil War veteran John Nichols was remembered. The Sons of Union Soldiers, members of the Nichols family, residents, town officials, and Wilton Heritage Society members attended the event. Mandi Wilder (left) and Melissa McConkey presented the flowers.

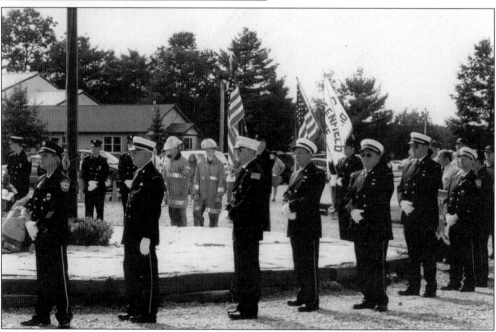

A remembrance of fallen firefighters and emergency personnel who lost their lives in the line of duty at the World Trade Center on September 11, 2001, was held at Gavin Park on September 28, 2001.